{ LEELANAU }

To Courtney ("Ranger Smith") —
With best wishes from
up in Michigan —

Jerry Dennis

Enjoy!

Ken Scott 12/2000

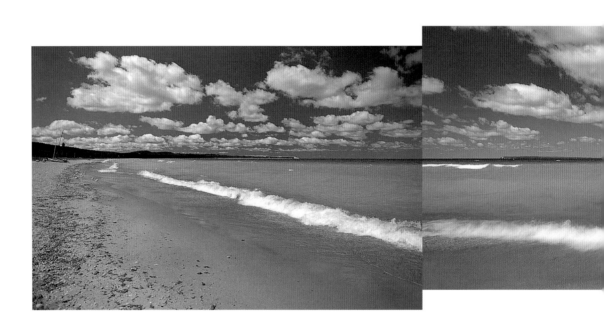

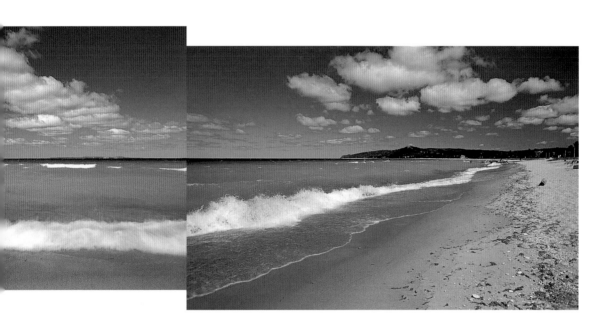

{ LEELANAU }

a

PORTRAIT

of

PLACE

in

PHOTOGRAPHS

&

TEXT

Photography by

KEN SCOTT

Essays by

JERRY DENNIS

PETUNIA PRESS

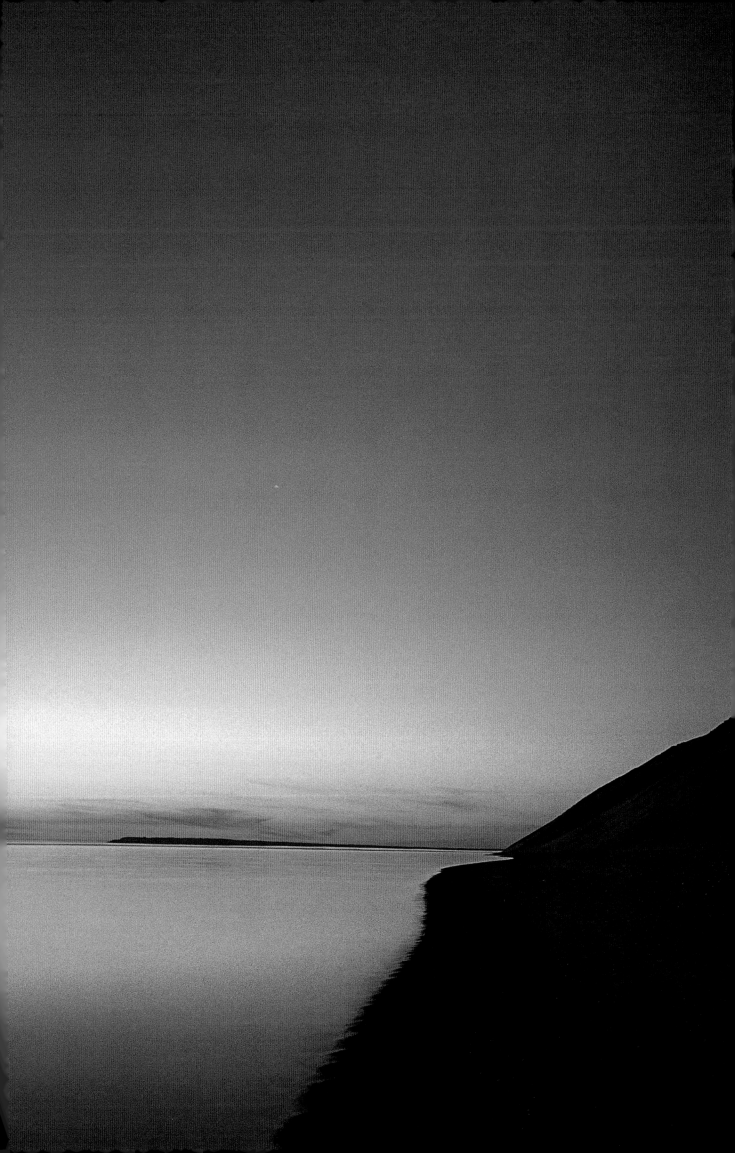

Dedicated to,

and in appreciation of:

Glen Clark

Gary Macaddino

Aaron Olson

Ron Shroyer

Anne Warren

—K. S.

To my grandmother, Ada Elmer,

and to the memory of

Forest Elmer, Clair Dennis,

and Elaine Dennis.—J. D.

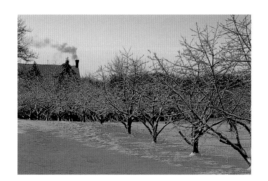

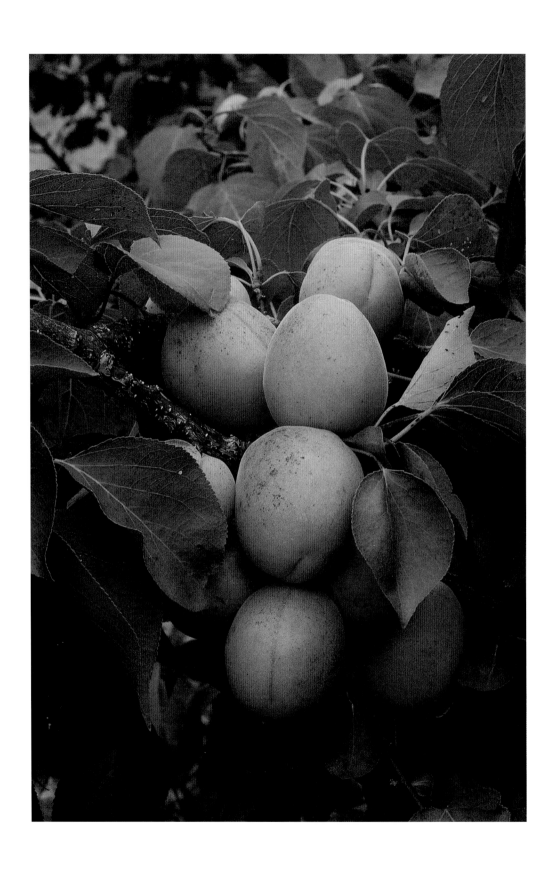

CONTENTS

{ *A Sense of the Place* } THE LEELANAU PENINSULA is one of those places that visitors love because it conforms so readily to their idea of it. It is a place to resort, to recreate, to escape the pace of city life, to find solitude and seek tranquility. In the slapdash language of travel magazines it is both a destination and a state of mind; a mecca for nature lovers; a precious gem awaiting discovery; the Riviera of the North and the Cape Cod of the Great Lakes.

Such designations mean nothing, of course. A place can't be captured in easy phrases. To understand Leelanau you must spend time there. To know the place—any place—you must invest yourself in it, dig into it with your hands and feet, bury your face in it, get a noseful, an earful, a mouthful.

It feels like home to me. I worked here summers when I was a kid, and year-round as a young man, and have lived most of my life within a few miles of it. I've hiked, fished, hunted, biked, camped, skied here; have returned for family reunions, graduations, weddings, and funerals. My mother and her sisters and brother were born in Glen Arbor and spent much of their early lives exploring the dunes, the woods, and the Lake Michigan shore. My father's family bought acreage in the southern portion of the county in the 1940s and established the original Sleeping Bear Farms, where they grew cherries and made maple syrup and raised palominos. Several dozen of my cousins, aunts, uncles, grandparents, and shirtsleeve relatives on both sides live here or are buried here.

So when Dianne Foster at Petunia Press asked if I would contribute some words about Leelanau to accompany a book of photographs by Ken Scott, I jumped at the opportunity. And not only because I care about Leelanau. I've admired Ken's photographs for years and was eager to work with him. I've felt an affinity for his work, just as I have for Glenn Wolff's, whose art has been integral to most of my books.

At our first meeting, Ken made a suggestion that became central to our collaboration. The conventional way to approach the project would

have been to produce text illustrated by photos, or photos supported by text. But convention does not suit Ken. He suggested we work independently, trusting that the results would be complementary.

With that in mind, trusting in serendipity, we set off to encounter Leelanau in our own ways. Mine involved a lot of hiking and driving and discussions about family history with my parents and grandmother. I took notes for a few months, then wrote most of the text in a house a few miles south of Leland. Every day for six weeks I composed longhand at a desk in front of sliding glass doors with a view of Pyramid Point across Good Harbor Bay. I wrote also at the dining room table, on the couch, at the kitchen counter, in the bathroom, in my truck, and on the beach. It was a rich and productive time. Already I miss it.

Ken's approach was very different. His photographs for this book are the result of several years of effort and much winnowing and sorting. They're the work of an artist who has achieved creative and technical mastery, and who knows his subject well, yet always finds new ways to look at it. I admire the world-view represented. To my eye, Ken's work is clear-headed, sensuously rich but never sentimental, unmuddied by ego or preconception, joyous and honest—qualities that apply also to Ken. He lives in Leelanau, in a house bright with colors and decorated with unusual art and an astonishing assortment of found objects. The downstairs studio has crept up the stairs to infiltrate the living space, and cats are everywhere. In his life and in his photographs, Ken reveals himself to be a man alert to the physical world, in touch with the wild, moved by beauty, and deeply enamored with light and movement.

The images do not come easily. To find them, Ken patrols the beach at dawn, sprints across fields in pursuit of thunderclouds, climbs hills at midnight to time-lapse the cosmos. He routinely slips through cracks in the world and enters the backcountry of the ordinary. When he returns he brings images that most of us can glimpse only in our most remarkable moments. They show deep feelings and great depths. We can see deeply into them—no easy accomplishment in a two-dimensional medium—making us realize that there is more to the surface of things than we suspected. They make a portrait of a place that must be appreciated at many levels to be understood.

Ask anyone from Michigan's Lower Peninsula where they live and they immediately hold up their right hand and point to a spot on the palm or fingers. Leelanau is the end of the little finger. It is bounded on the west and north by Lake Michigan and on the east by Grand Traverse Bay. The peninsula measures approximately twenty miles wide at the base, where it is widest, and is thirty miles from south to north. Its shoreline is among the most interesting on Lake Michigan, with many miles of sand beach, occasional jumbles of rock, and some of the largest freshwater dunes in the world. The dunes, thirty-five miles of shoreline, and South and North Manitou Islands are included in 72,000-acre Sleeping Bear Dunes National Lakeshore, which is the primary tourist magnet in Leelanau, drawing some 1.3 million visitors each year. Inland are rolling hills and forests, interspersed with farms and orchards and many lakes, most notably North and South Leelanau and Big and Little Glen.

Most of the perimeter is traced by M-22, certainly among the most scenic highways in Michigan. Within the county are a dozen villages and a combined population of fewer than twenty thousand people. Perhaps the most revealing facts about Leelanau are that it contains no mini-malls or strip-malls or malls of any kind, and that in all the county there is but one fast-food restaurant and one traffic light—and both are in Greilickville, on the outskirts of booming Traverse City.

People who live in Leelanau or have been visiting for years can be ferocious in their determination to protect it. In a world of rapid change and frenetic lifestyles, Leelanau remains quiet and rural and slow to change, and thus increasingly important to our collective well being. It is one of the last good places. I hope this book does honor to it.

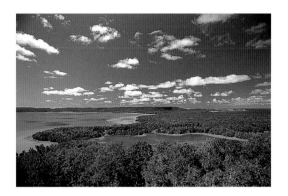

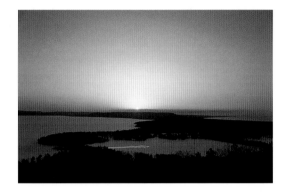

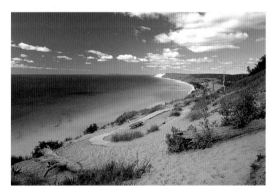

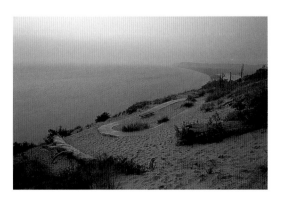

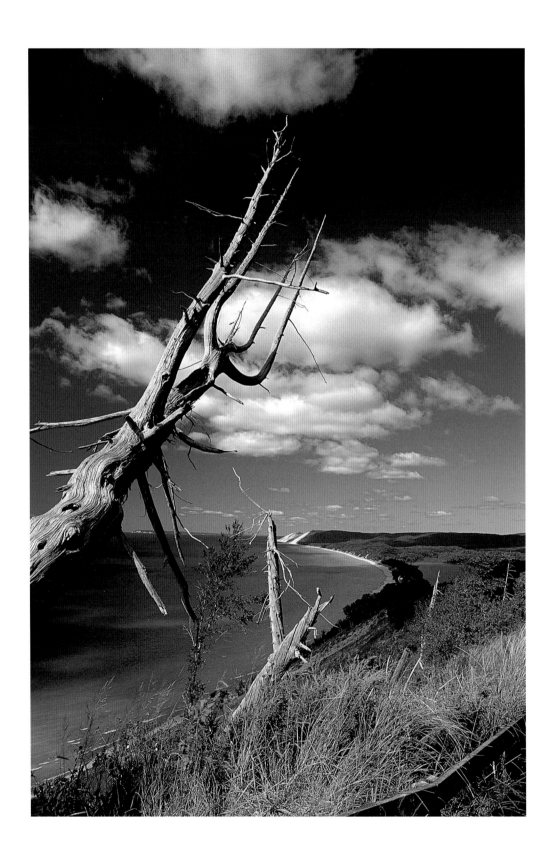

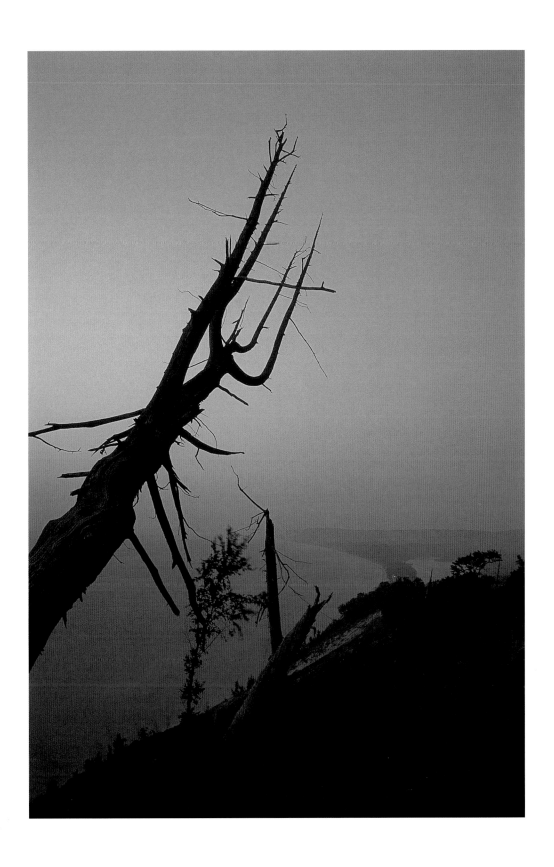

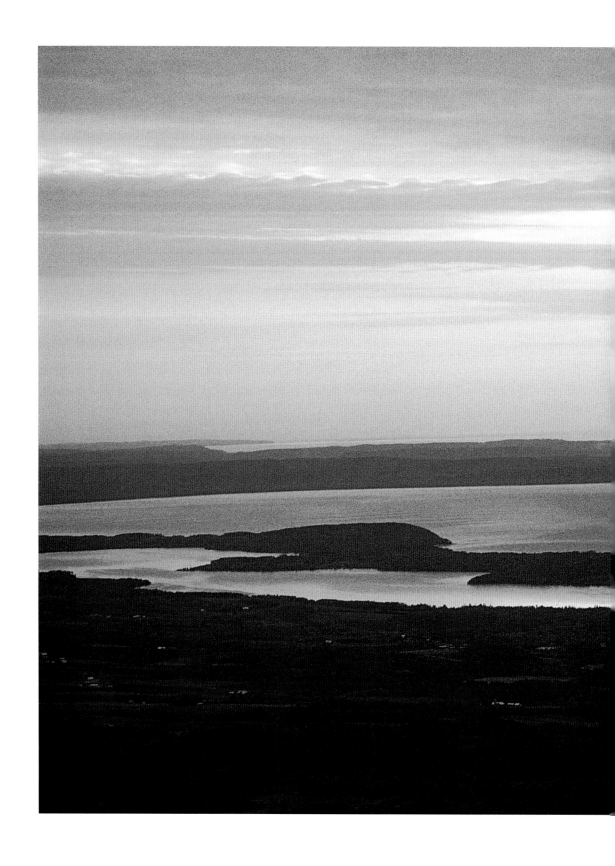

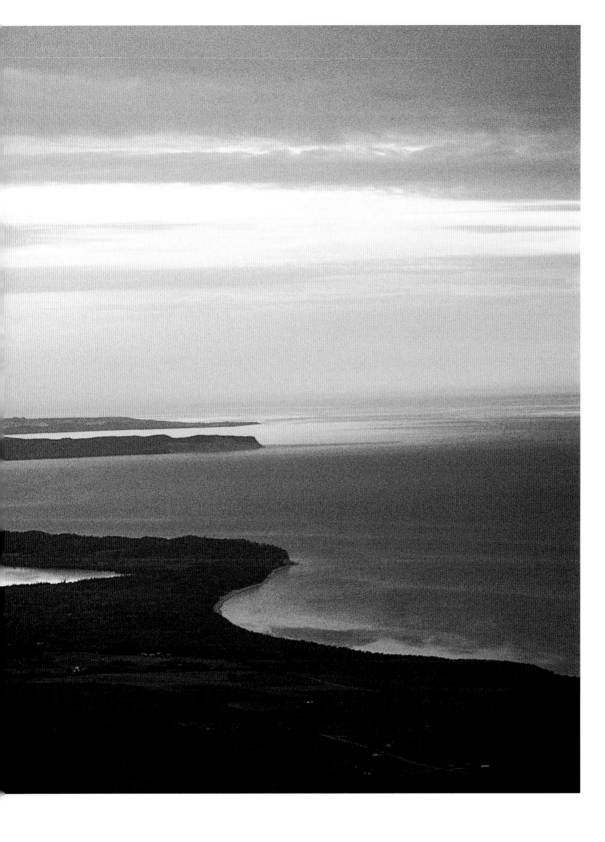

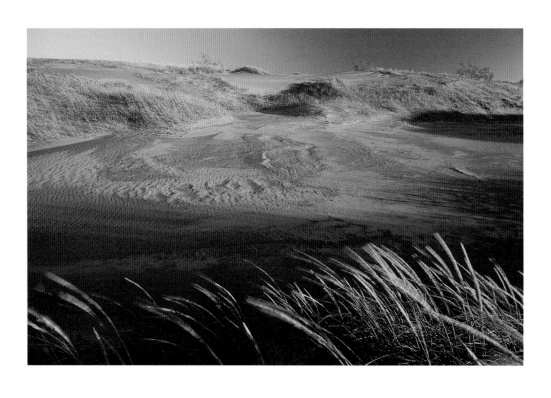

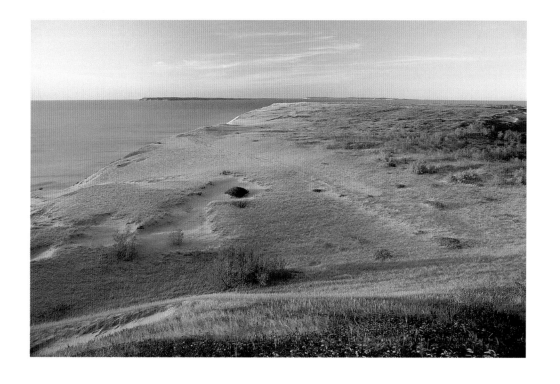

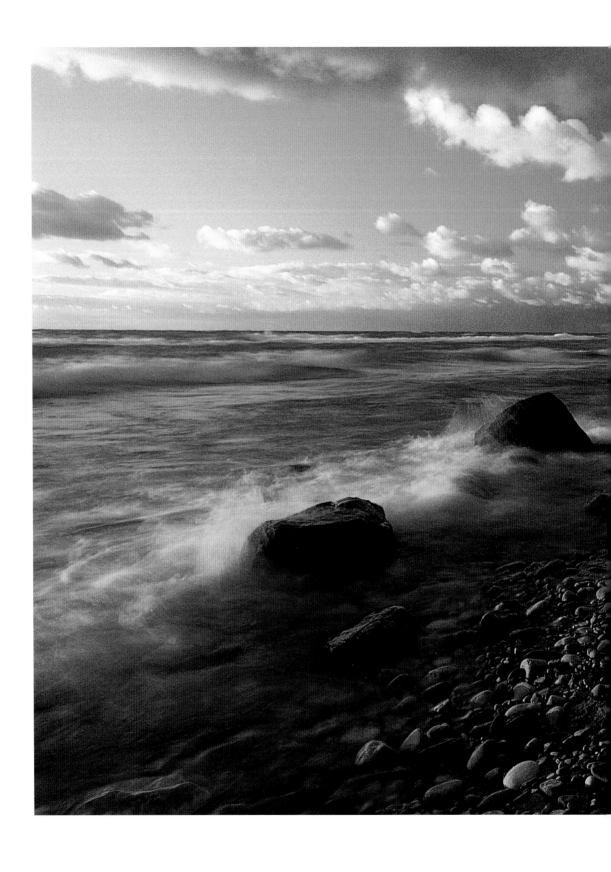

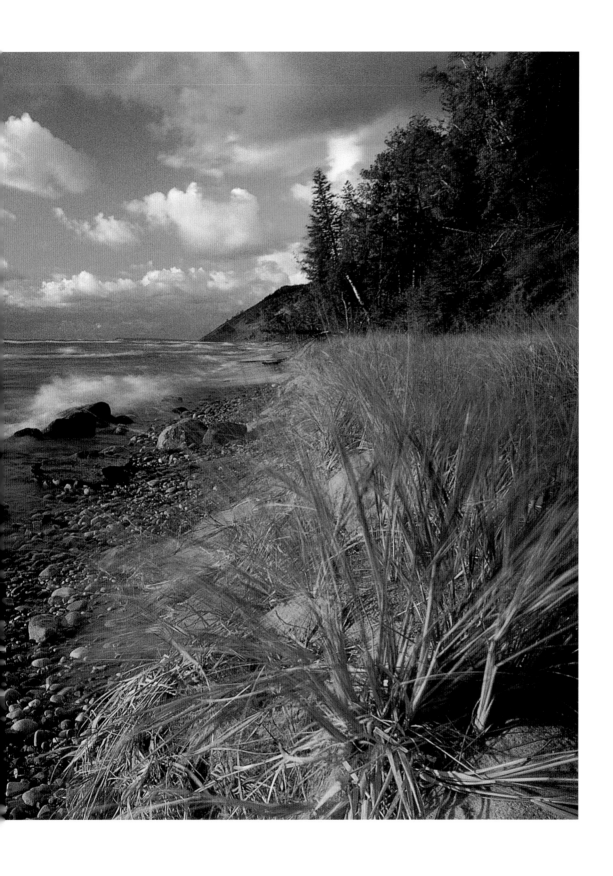

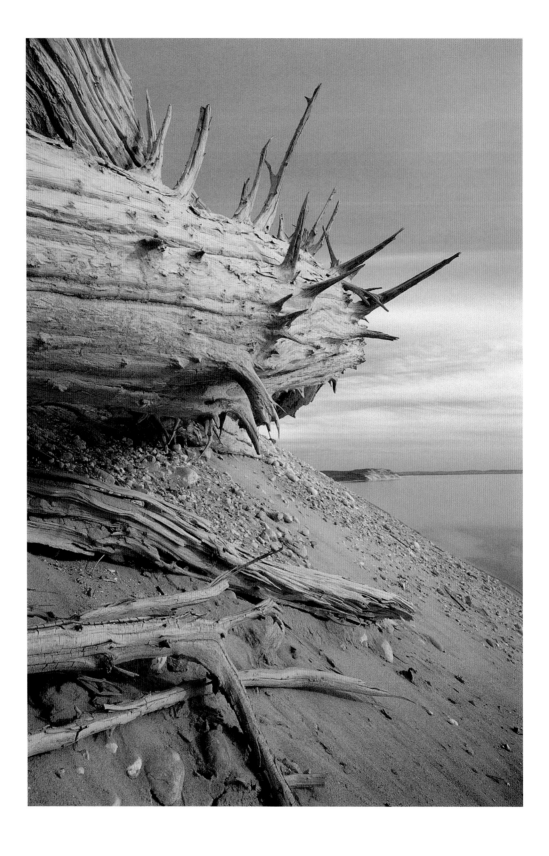

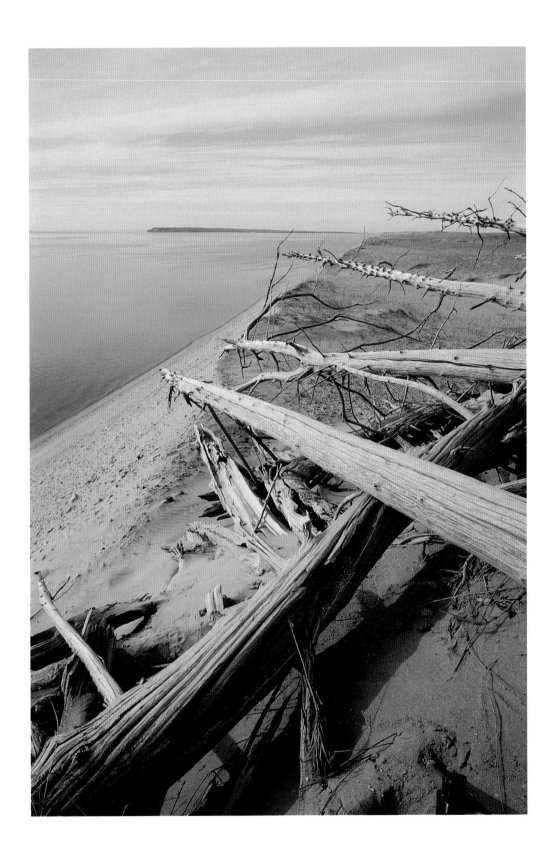

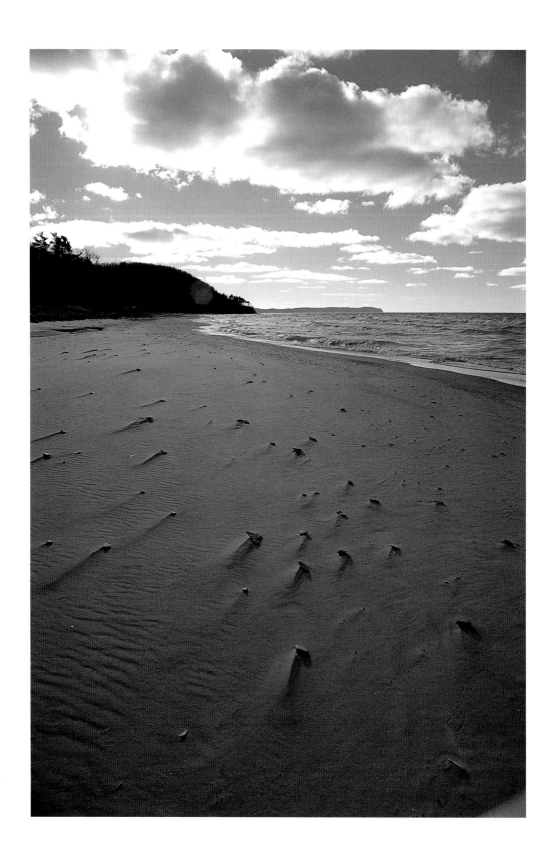

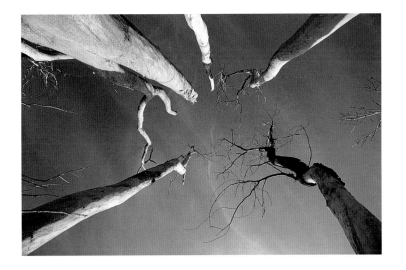

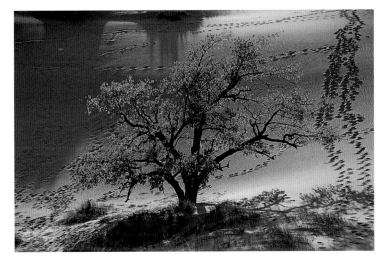

27

FAR AND NEAR

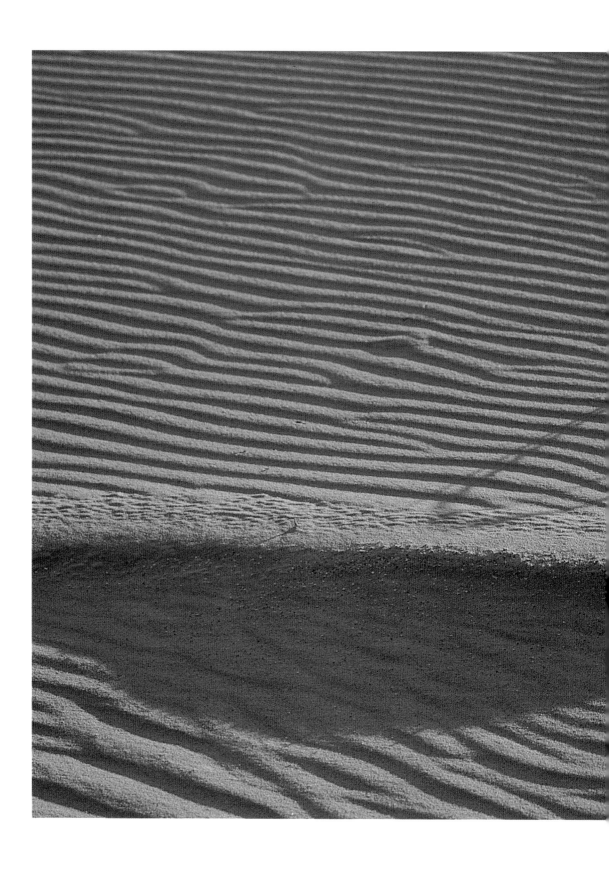

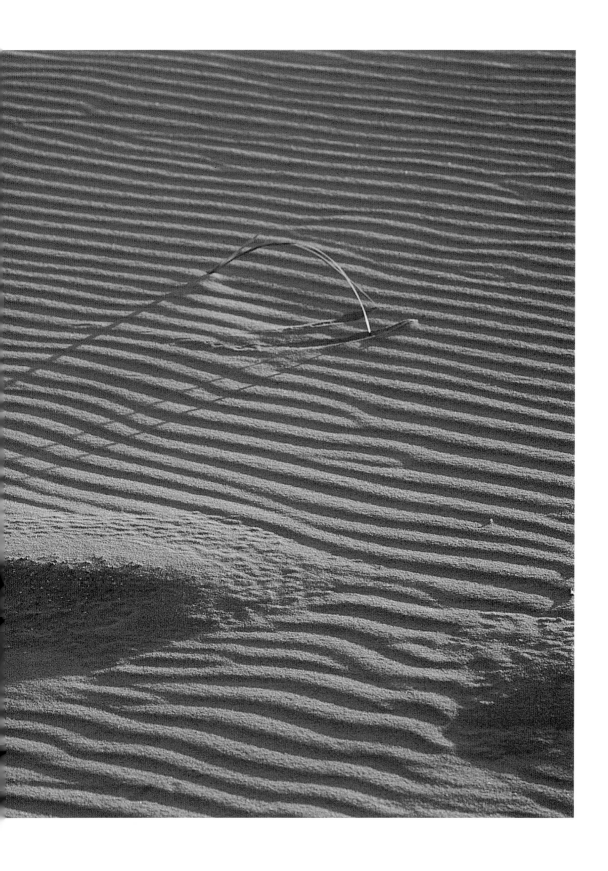

FAR AND NEAR

 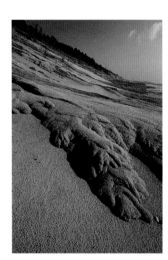

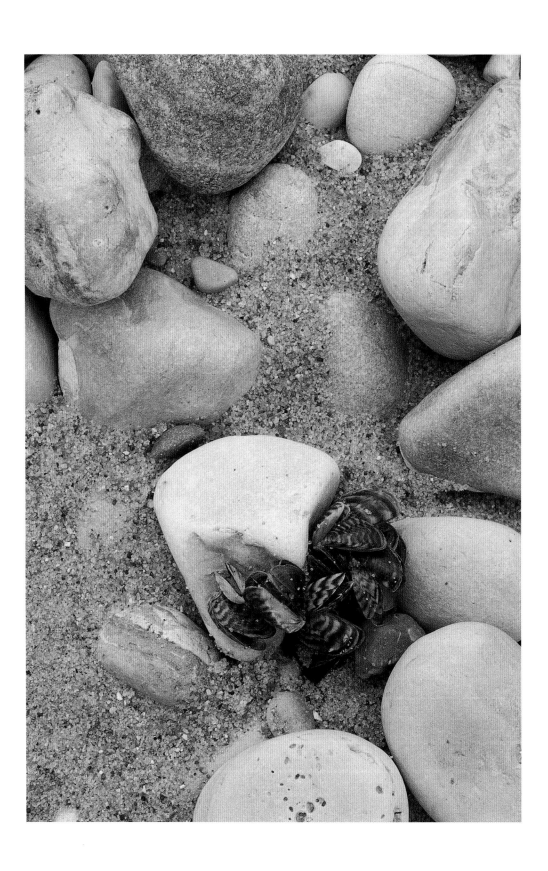

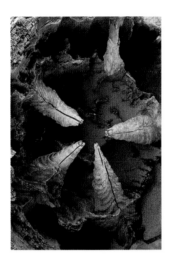

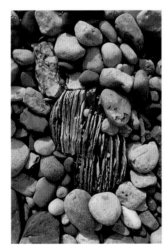

{ *Hilltops* } Most of our views are close ones. Our vistas are short, our woods opulent. We could be accused of myopia, so accustomed are we to seeing only a few steps ahead. Drop us on Nebraska prairie or the crest of the Rockies and we fall whimpering to our knees. The sky is lovely, but not when it swallows the world. We want exposure, but in moderation. A hilltop, with woods below and behind, is about right.

Who can resist climbing hills? From a promontory we can see places we want to be—see, for instance, if a river that flows generally north gets there first after a long dogleg to the west, or if a pond can be reached from the highway or only through the swamp on the other side. It's the best way to understand topography, how land and water work together, and to perceive how forces from the geologic past have shaped the present. Climbing to a height and looking is probably instinctive. It provides a defensive position, insurance against getting lost, a way to take stock of where we've been and where we're going. Without that long view, we're likely to get lost in short ones.

Leelanau's hills are not large as hills go, but are closely situated gatherings of sand and gravel deposited by the glaciers. The highest of them are only five hundred feet above Lake Michigan, a thousand above sea level, and give prospects of other hills bunched like rugs, with shadows of the clouds crawling over them. Beneath the hills are valleys busy with orchards, fields, woods, and swamps; beyond the hills is a rolling horizon or the oceanlike expanse of Lake Michigan. Much of the land is wooded—more now, perhaps, than at any time in the past century and a half—and where streams flow no water is visible. Instead there is a vaguely organized parting of the woods, like the path of a snake on wet lawn. In winter, when the leaves are down and snow covers the ground, you can see white beneath the trees, like scalp through thin hair. Orchards blanket the slopes in meticulously combed rows.

To nobody's surprise, houses dominate many of the summits of Leelanau. They look like the castles of minor dukedoms.

For a slice of Leelanau, take the left fork of the road up Miller Hill and pull over at the overlook by the power lines. Most people park at the turn-

around, get out of their cars, and lean against the guardrails.

In the far distance is the Manitou Passage between Sleeping Bear Point and South Manitou Island, and the open lake beyond. In the near distance is Tucker Lake and its fringe of drowned trees, and, beyond it, the Crystal River, visible only as a winding notch through the trees. Past Glen Lake rises the prominence called Alligator Hill, which blocks a view of the dunes. In summer the hardwood canopy is interrupted by lacy stands of locust and the silver-dollar shimmer of aspens. Throughout are veins of dark evergreens, with occasional spires reaching branches wide, like arms opened to the sky.

When I want friends to understand Leelanau, I take them first to prominences like Miller Hill, Pyramid Point, Whaleback, Inspiration Point overlooking Big Glen, and the Empire Bluffs. The Bluffs are especially rewarding. The trail there requires a steep hike, and offers views from several vantages. At the top, where the bluff falls 350 feet to the lake, are ghost forests long ago inundated by sand, then exposed to the air again and weathered. Around you is more water than land, and more sky than either. Your eye follows the ribbon of beach culminating at Sleeping Bear—a shock of yellow sand against blue sky and blue water. The water is so clear that you can see the dark beds of zebra mussels on the bottom a quarter mile from shore. One summer day when I was a kid my parents, brother, and I stood at this outlook and watched three sturgeon swim slowly along the shore beneath us. They were black and enormous, the size of ocean creatures—ageless denizens of a place we could never reach.

From this height the details of water, beach, hills, and woods are softened and perspective gets skewed. On the horizon, plodding freighters as substantial as small towns look puny. A tourist from England approached the edge of the bluff and I overheard him ask his companions, "Can you see Wisconsin?" The distance was too great by far; the Englishman could see only the horizon line, vague with haze. Strangely, he seemed disappointed.

From a hilltop it's possible to sense nature's patience, the slow crawl that fills lakes and wears down hills and covers every valley with forest. Stripped of trees, the torso of the land is revealed as glacial outwash—heaps of debris, barren channels, the dredged and plowed remains of a great scouring. Ice a mile high once stood here. At its edges the ice calved and groaned;

it splintered rock with its weight and shoved stone and sand into small mountains. From fissures in the ice roared rivers of meltwater white with pulverized stone or brown with sand, ripping gullies as they descended, carrying boulders that banged together and filled the air with tumult. The rivers carved valleys, spread in meandering braids, changed course and left ponds and oxbows and bars of gravel sorted by size.

The land is in progress. The level bench of woods between Little Traverse Lake and Good Harbor Bay once was lake bottom, and Little Traverse was the deeper swerve of the bay. Land that was bare sand and stone became tundra, then was covered with stunted black spruce like those growing north of Lake Superior, and was replaced with hardwoods. Some of the hardwoods were cleared and the land was cultivated for crops and planted with orchards and vineyards. When the farms are abandoned, the forests return.

From a hilltop you can watch the weather, can witness the approach of thunderheads and squalls. You can see geese come from the north and disappear to the south, can watch hawks kettling and song-birds darting.

You can gauge the geometry of human endeavors—the roads and powerlines; the carelessly assembled squares and rectangles of farms, yards, and towns; the corridors of industrial growth; the subdivisions creeping up the slopes.

From a hilltop you see only what has been grossly altered. You're reminded that though we control some of the little things, the big things happen on their own.

You can stand on a hill, watching, and plan a year's worth of outings and dream a decade's worth of dreams. You can talk about perspective and the long view and the best ways to protect the land. You can brag that you have a better view than anyone.

But you can't stay there. Eventually you have to come down. It's rank and hot in the valley, the trail is muddy, and you can see only a few feet in any direction. Yet that's where most of what matters takes place. Stay on your peak as long as you can—fight for a toehold if necessary—but below the hill is where life gets lived.

WE'RE FORTUNATE in northern Michigan to do much of our traveling on country roads, fortunate also that our roadmakers seldom had the luxury of plotting the shortest route between two points. They were forced instead to follow the contours of the land, seeking plateaus, ridges, and valleys, getting nudged off course by bluffs, marshes, ponds, and lakes. If many of our roads have the circuitous and seemingly aimless appearance of game trails, it's because they began that way. On the best of them, even at forty-five or fifty miles per hour with the windows closed and the radio on, it's possible to feel yourself wandering rather than hurtling across the land. Go slower, with the windows open, and you seem to meander through an older, slower age.

Leelanau is a peninsula upon a peninsula, surrounded on three sides by big waters and infiltrated throughout by smaller ones. There's so much water that the land is defined by it, producing many small points, isthmuses, swamps, and bogs, and inspiring almost as many Harbour Views, Bay Views, Bay Valley Estates, and Chateau Baysides. Our roads could not be built geometrically, as they were across much of the agricultural Midwest, where sectionline roads were laid in precise square-mile grids, oriented north-south and east-west, as straight as draftsmen's rules could make them. Roadmakers in Leelanau had to be pragmatic. They could rarely indulge in right angles, were never privileged to see their work run true to a perspective point on the horizon. Instead they let the roads curl, cut back, loop around, and roller coast. As kids we rode standing behind the cabs of our fathers' and grandfathers' pickups, gripping the rain gutters, leaning into hills, bracing our thighs hard against the centrifugal pull of curves, first one way, then the other. We knew the shapes of the roads in our muscles.

When we pedaled our bikes to a friend's house or to the store for pop and candy the route wound through so many curves and rose and fell over so many hills we seemed to go twenty miles, not two. It was an expedition. We took lunches and canteens along, and emergency matches and pocket knives. Along the way we might find ourselves momentarily in a woods, at the edge of a field, with a wedge of blue lake visible between hills. But the setting changed every time we rounded a curve or climbed a hill, so we could never see where we were going or where we had been, only where we were. There was virtue in that. Curves and hills in abundance and

irrational intersections kept us alert to the world as we found it.

A country road, to qualify, must be gravel or roughly paved, and relatively narrow. Six paces from edge to edge is about right, although less is better because it forces opposing automobiles to slow. If there must be a center line, let it be so old that the yellow paint has settled into the asphalt, giving it the patina of a 1933 license plate nailed to the wall of a garage.

Nature is nudged aside by country roads, but it crowds the border. You can step off the shoulder into lush meadow grasses and milk-weeds and the shade of overarching maples. A shrew hunting blindly bursts into the open, finds itself suddenly exposed on pavement, and dashes across to the weeds on the other side. If the road were abandoned, roots would soon hoist and buckle the pavement and seedlings would pry through every crack. In a few years it would be overwhelmed, like a temple in a rainforest.

One of the delights of country roads, in contrast to superhigh-ways, is that they can accommodate traffic other than cars and trucks. Pedestrians, horses, wagons, bicycles, and tractors are as welcome as Fords and Hondas. Walk your dog on a leash and you'll end up smiling at folks on horseback, nodding at joggers, striking up conversations with interesting people of all sorts. Someone pulls up beside you on her bike and asks if this is the road to Isadore. Nice looking dog, she says, what breed? A farmer on a tractor slows and nods and doesn't accelerate again until he's far enough past to soften his exhaust and mute his engine roar. People in cars make eye contact, and someone usually waves. If you can't see through the windshield glare, you get in the habit of waving at everyone.

For an example of what I mean, go to Wilco Road behind Empire, where it winds through a taut and narrow valley of hardwoods to the bluffs at the old airbase. This is the route water took when it poured from the face of glaciers; now it's a lazy ramble through the woods, a glissade, a serpent trail of a road.

Or go to Stocking Scenic Drive, that tourist trip with paid admit-tance required. It's a must-see in every guidebook and for good reasons: The road and bike trail pass through mature woods, cross a covered bridge, and culminate at the roof of the dunes.

Or Day Farm Road, canopied by maples and concise, as neat and meticulously planned as the Day Farm itself. It ends at equally concise Stocking Road, which curves past the site of an old lumber mill, gone now,

where my uncle Eldon grew up, and slips through gateposts at M-109, making it a semi-secret shortcut to Glen Arbor.

Or Schomberg Road, south of Leland, a drumlin tour with roly-poly views of glacial work. Those bald bumpy hills and valleys were cleared by farmers more ambitious than most; where the hills have gone fallow, you can see the bones of the planet beneath them.

Or the county roads west of Northport: Johnson and Onomonee roads, also Melkild Road and Foxview Drive and Peterson Park Road—all winding, hilly, through wild woods, past neat-as-a-pin orchards and abandoned farms overgrown with summer grape, topping crests that give unexpected views of the lake and the Manitous.

Or Eagle Highway, Kolarik, Dumas, Setterbo, and Swede roads northwest of Suttons Bay, where they ramble through farms, below ridges lined with disciplined rows of Lombardy poplars, and long views over hills, swamps, woodlots, and orchards to the big lake and its smokey horizon.

Or Hlavka Road, off Maple City Road, through a pristine wooded valley where runoff once roared.

Or Burnham Road, west of 677, with its gravel laid straight beneath a canopy of maples and beeches.

Or Valley Road, south of Maple City, where it sashays through a vale of maples sheltering a trillion trilliums and a few hippy houses.

Or Kasben Road, south of Cedar, with its frontierlike pastures backed against cedar swamp and fenced at the road with barbed wire strung between posts of any length that came to hand. There, too, is an honest-to-God junkyard, with every vehicle the family has ever owned parked in the woods around the house, the oldest of them rooted to the ground by trees through their floorboards, and a tractor-powered mill surrounded by stacks of roughsawn planks and mounds of decomposing sawdust.

When I was a kid, places like that could be found on every back road in Leelanau. Grandpa would yell into the house to say we were going to the junkyard, and I would climb into the truck with him and ride down one of those winding bumpy roads that always got me lost two or three intersections away from the farm. As we drove I'd be treated to a running commentary on the history of every orchard along the way, with remarks on the turpitude of owners past and present, and asides about the history of a fishing trawler rotting on blocks in the woods or an abandoned house on a

hill or a scarred cottonwood on the outside of a dangerous curve.

Eventually, we pulled up to an unpainted house with a baredirt yard full of junk cars and barking dogs straining against their chains, and Grandpa got out and stood in the driveway with a big man in coveralls covered all over with grease and they talked about this and that and a little about everything else. After a while Grandpa said he didn't suppose a fellow could go out back and find a fuel pump for a '46 Dodge. The guy in coveralls thought about it for a minute and scratched himself and thought about it some more and finally said there was a pretty good chance a fellow could do just that. Then the three of us walked out to the tool shed or the barn or the overgrown rows of junkers to look for it.

Sometimes we found what we were looking for, sometimes not. Either way the search took most of the afternoon, and we always drove the long way home.

———————

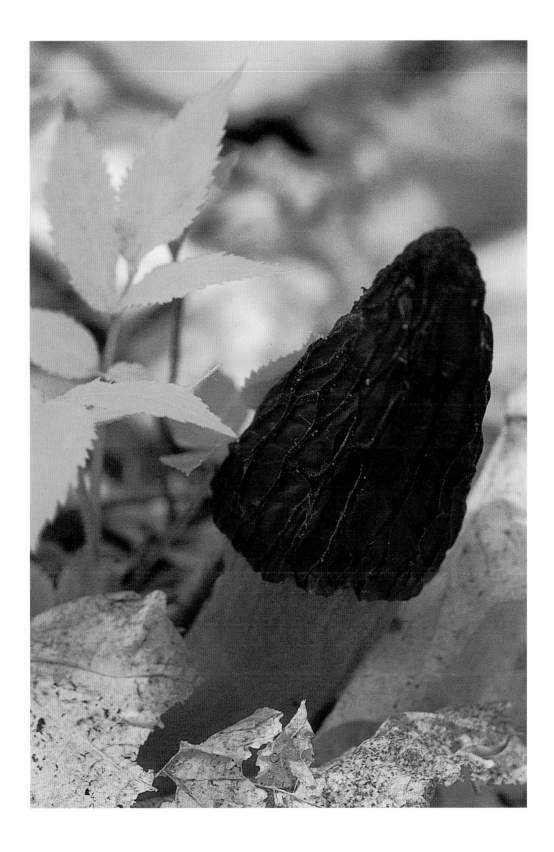

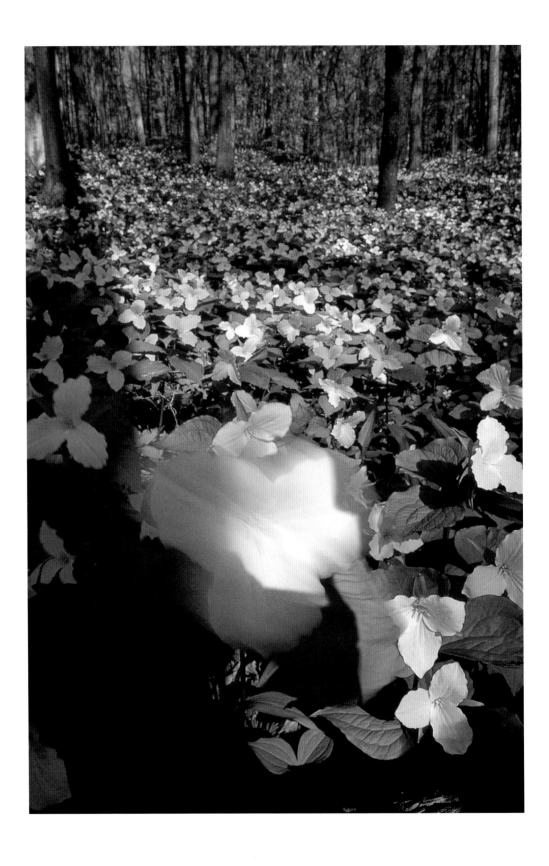

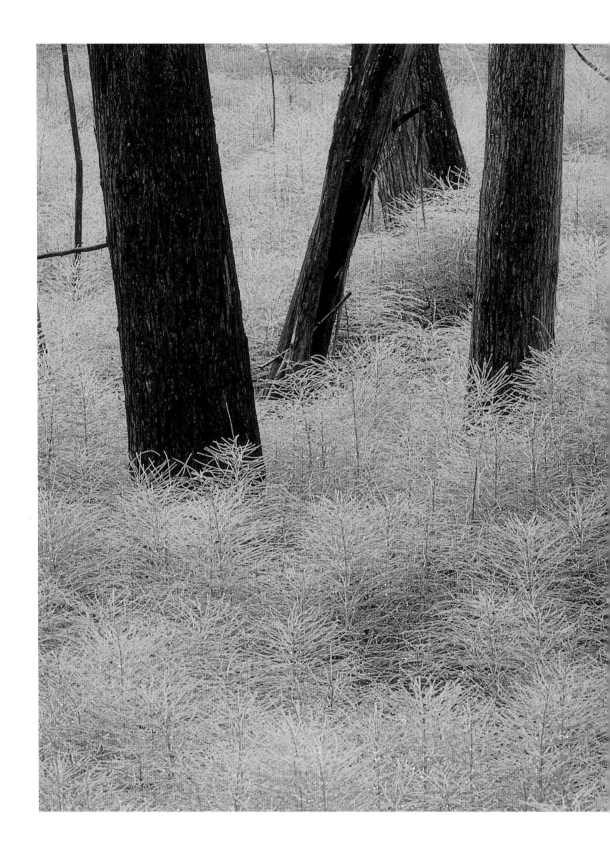

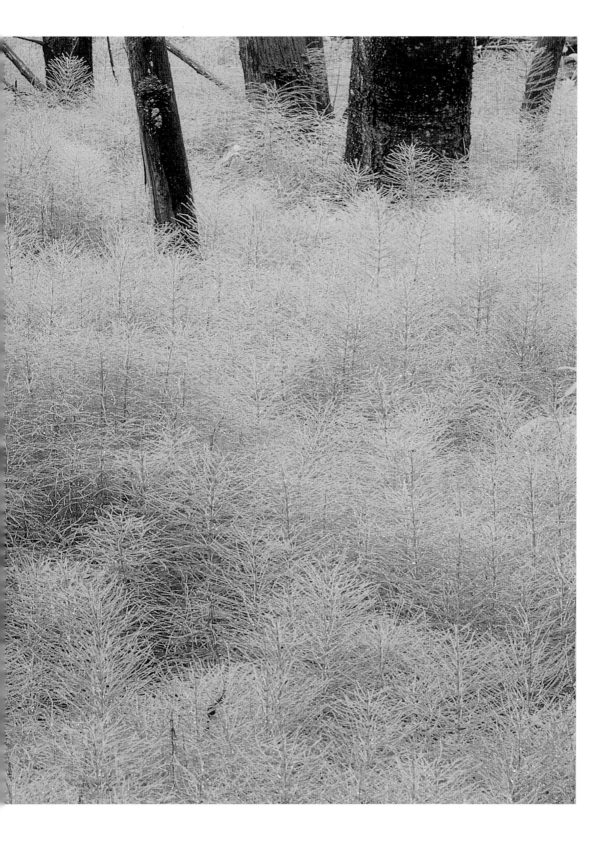

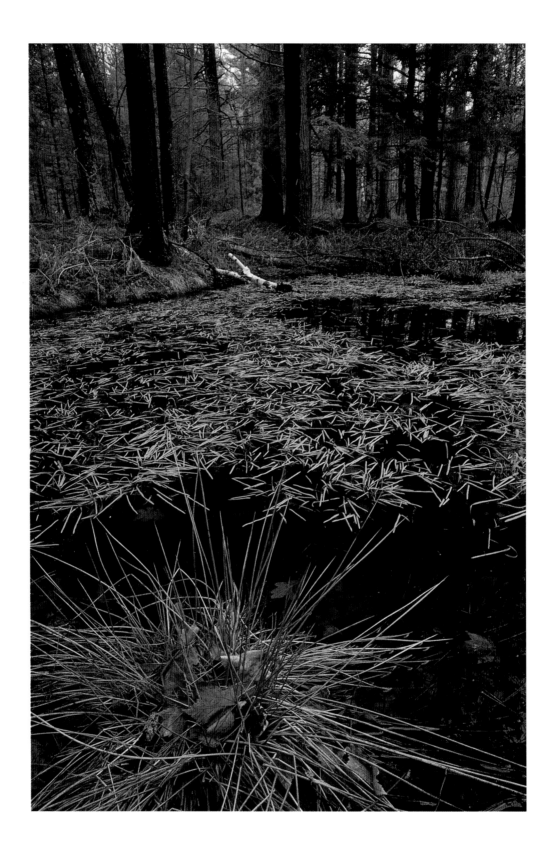

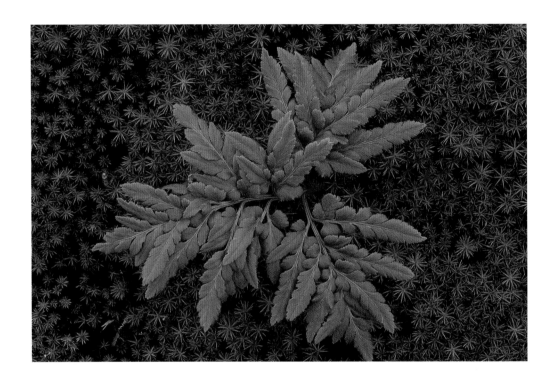

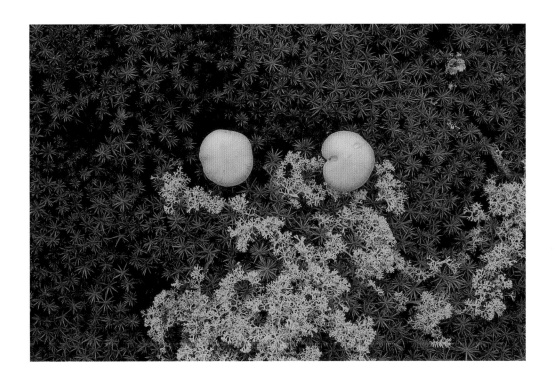

FLORA

FLORA

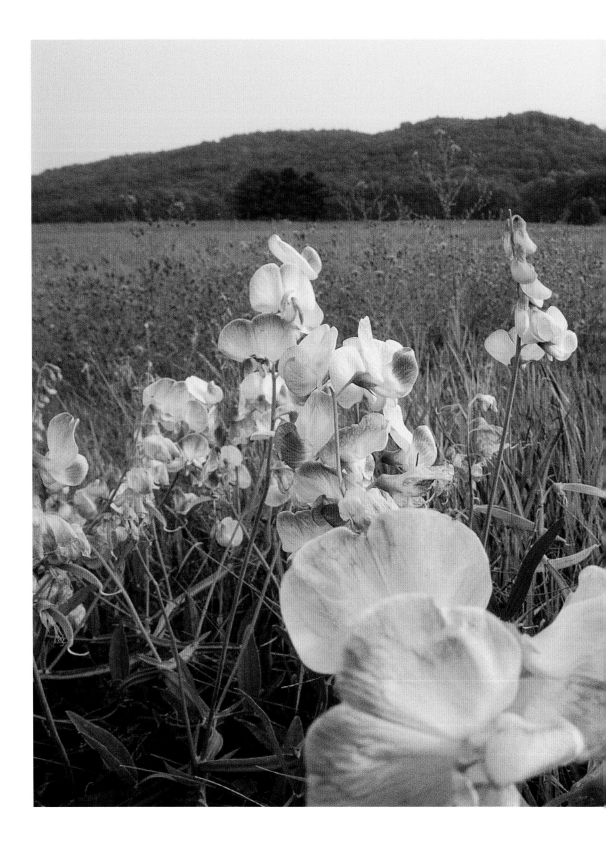

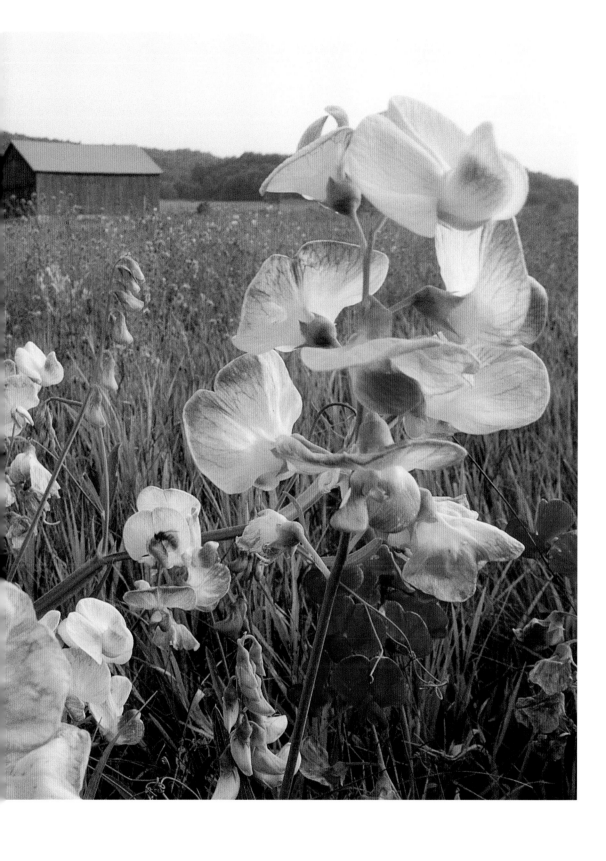

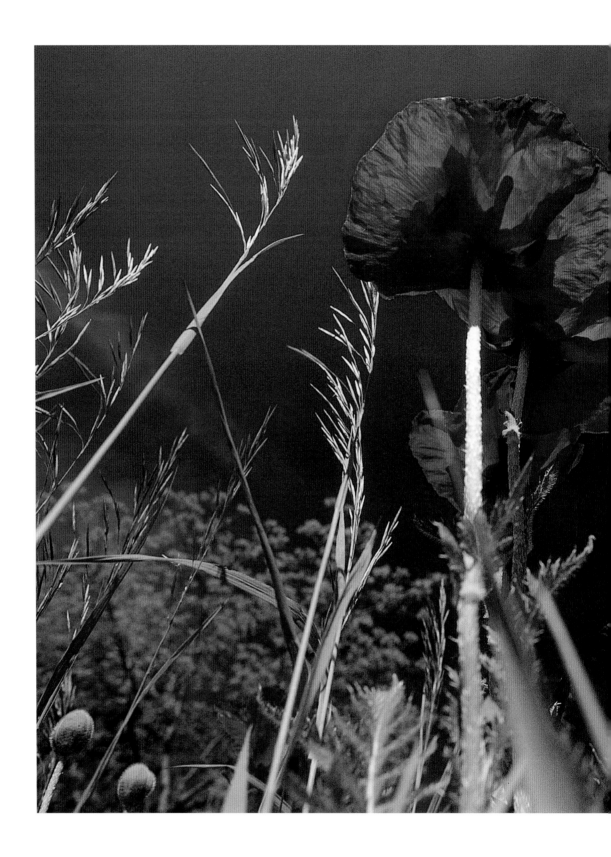

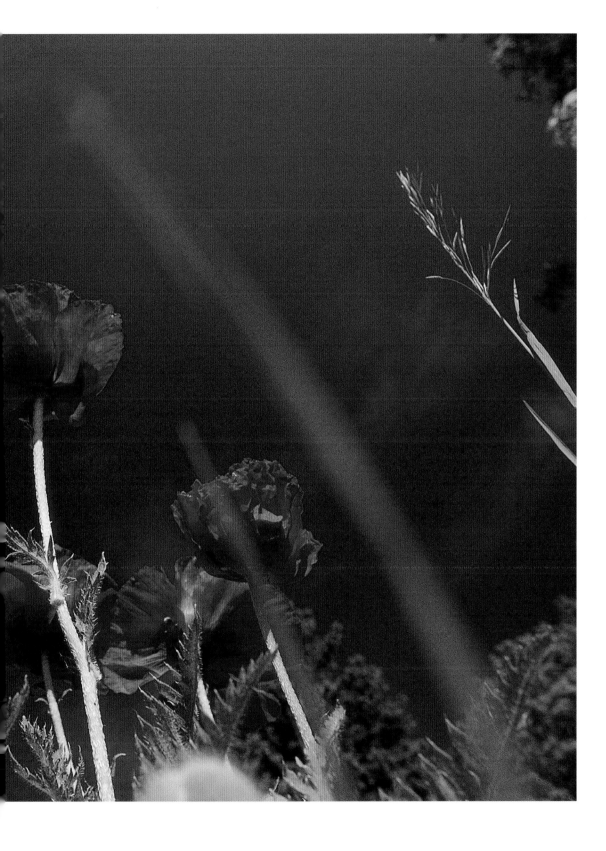

{ *Homesteads* }

APPLE TREES AND LILACS give them away. The trees are gnarled with age but still produce small wormy apples; the lilacs grow in mounds as big as houses and produce mountains of blossom. Nearby you're likely to find the shallow remains of a basement or root cellar, and maybe an old foundation made of fieldstones held together more by habit than mortar, filled with raspberry thickets impenetrable to all creatures except field mice and snowshoe hares.

You can usually find the rubbish heap behind the house. What once was trash has been time-washed into treasure. Toe around among the rusting tin cans and broken jars and you'll find many small artifacts that were part of someone's daily life: a decaying rubber boot, a perfume bottle, a steel bicycle seat, the handle of a mug, half a porcelain plate webbed with tiny cracks and decorated with faded bluebirds. Here and there is a label that can help date the place—

> *NEHI Beverages 7 oz*
> *(Bottle sterilized before filling.*
> *Property of Nehi Bev Co Gr. Rap Mi)*

The size of the farms varied, depending upon the ambitions of their owners and factors such as the proximity to roads and bodies of water. Homesteaders arrived in steady numbers following the Homestead Act of 1862, which gave 160 acres to anyone willing to pay a small fee and live and work on the land for at least five years. By 1863 there were 2,158 settlers in the county, most of them farmers and lumbermen.

Farmers supplemented their incomes any way they could, most often by providing firewood for the "wooding" industry that grew up along the coast. Steamships from Chicago needed to take on fuel by the time they reached the Manitou Passage, and many enterprising individuals made it available. They built docks where the ships could tie up and carted wood by the thousands of cords from the interior of the county to the waterfront. A farmer clearing land could sell his wood if he was near the wooding stations or near waterways that allowed him to float rafts to the markets; otherwise it was often cheaper to burn trees where they fell. Steamships required wood in four-foot lengths, split, and the going price was two to four dollars

for a full cord (four feet by four feet by eight feet). By the end of the 1890s, when the wooding industry ended, at least twenty wooding docks were in business around the shores of the Leelanau Peninsula and Manitou Islands. Northport alone sold 35,000 cords every year. All those docks are gone now, but the pilings still stand in the water off Empire, Glen Haven, Good Harbor, and elsewhere.

Many old farms reveal the work that went into making them. You can look out over rolling, once-tilled land, much of it grown wild again with field grasses and wildflowers and sparse stands of young aspen, and feel the rocky soil through wooden plow handles. Along the fencerows are low piles of stones that have been picked from the fields and deposited there by hand, one at a time, year after year, decade after decade. From a distance they have the color and shape of potatoes, the crop that more often than not took their place. Not many potatoes are grown here now, and not many fields are cultivated.

I don't know how many acres it took to support a family in the nineteenth century, but the lean, asymmetrical fields carved from the woods in Leelanau make it easy to believe that not a single tree more than necessary was cut. When settlers came, the land was covered with forests, mostly hardwoods, with some stands of pine and hemlock and many dense cedar swamps. To build a pasture or potato field every tree had to be axed and sawn to the ground, then cross-cut into lengths for firewood or lumber, the tops bonfired, the stubborn stumps removed by any method that worked. Sometimes they were pulled from the ground by horse or mule. Sometimes they were ditched all the way around with pickaxes and shovels, the tough bouncing roots chopped and torn at until the stumps rolled free. Often they were burned. Occasionally they were dynamited. It was said that a single oak stump could consume a week of a man's life. Dozens needed to be removed from every acre.

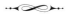

One summer day in 1970 I packed a lunch and a canteen of water, climbed to the top of the dunes, and hiked roughly west, planning to explore the least accessible corner of Sleeping Bear. I wandered off course a bit, which is easy to do in the dunes, where once you lose sight of the lake every direction looks pretty much like every other direction. But I had no excuse

other than indifference. I didn't really care where I went. To get my bearings, I climbed to the top of a bluff and found myself a hundred yards from a windswept beach near Sleeping Bear Point. It was a place I had never visited.

On the backdunes I discovered traces of habitation. The glint of glass attracted me first, then fragments of wire fencing and the rectangular outline of a stone foundation nearly covered with sand. Nearby were remnants of a fireplace and a few weathered roof timbers. I dug around in the sand and found intact canning jars dating from the 1850s and patent-medicine bottles made of rainbowed glass with strange tradenames in raised letters. I also found the porcelain handle of a faucet, a dozen ivory buttons, numerous square-headed nails, and a perfect clay marble. I imagined that only I knew about the old settlement, and I was certain there must be treasure.

After exploring the site for an hour or two, I wrapped a few jars, medicine bottles, and some of the smaller artifacts in my shirt and placed them in my daypack, and struck out along the beach toward Glen Haven. I intended to return the next day with a metal detector I had ordered that summer for twenty-five dollars from an advertisement in the back of *Field and Stream*. It required using a transistor radio for a speaker, which I carried in my shirt pocket and had to fiddle with constantly to keep the proper frequency, and would sometimes but not always emit a rousing "Whoop!" when I passed the head of the detector over coins I buried an inch beneath the grass in our yard. I imagined the noise it would make when it passed over jars of silver dollars buried in the sand.

I couldn't make it back to the dunes the next day, nor the next week, and suddenly school began and I decided to wait until the following summer to do my prospecting. And one day that winter twenty acres of dunes and shoreline broke free and slumped into Lake Michigan. Millions of cubic feet of sand disappeared into the Manitou Passage that day, and with it went every trace of the old buildings and the refuse heap I had found. If any remnants remained, they were almost certainly swept away by an even larger landslide in 1995, when an additional thirty-five million cubic feet of sand slid in a long tongue of debris more than two miles into the lake.

Not all of Leelanau's abandoned homesteads are in ruins. Some remain standing, a tribute to the quality of their construction and to volunteers in recent years who have worked to preserve historic buildings in the national park. Elsewhere in the county are empty houses, barns, and outbuildings undergoing a slow tumble. No paint remains on their walls, no glass in their windows, and their board siding has been weathered like driftwood.

In the miter of a window frame, still tight after a hundred years, you can see the hand of the builder. You notice a rusting 16-penny nail in the trunk of the walnut tree outside the back door, and it's easy to imagine a man at the end of a summer day hanging a bucket of water there, removing his shirt (his neck and hands tanned dark, his arms and back stark white) and unwrapping a bar of soap from a square of linen.

Who says there are no ghosts? Stand in that yard overgrown with thistles, step inside a doorless doorway, and you know there were births and weddings and funerals there, harvest parties and kitchen work-bees and Sunday afternoon softball games and winter evenings by the stove and Christmas mornings by the fireplace and dogs asleep on the rug and children's feet pounding up the stairs and laughter and crying and singing and arguing and quiet lovemaking and coughing in the night and frost on the windows and bathtubs steaming and infants asleep in their cribs and the scent of baking bread and piano music and stories told and dreams shared and candles throwing shadows on the walls.

What becomes of a life? It returns famously to dust. But first are fragments.

On a sandy blowout at Good Harbor is a mosaic of glass fragments in a dozen colors, each piece sandbuffed foggy by the years. The glass glitters in the sun and appears to be as old as obsidian.

There too are hundreds of bent and deteriorating nails, square heads and round heads, all bronzed with rust, as pitted and worn as ancient iron weapons.

And a straight-pin tarnished to pewter, bent like an insect's leg.

And shreds of window screen as fragile as ash, coming apart into tiny t's and x's on the sand.

{ *Old Trees* }

OLD TREES WERE OLD before anyone we know was born. They're old and they're big—it takes a crowd of kids to embrace them all the way around—and so prominent they become landmarks. Tell a friend to meet you at The Old Oak and your friend knows exactly where you mean: the place where her childhood bloomed on a rope swing, where her parents fell in love, where her grandfather's father once tied his horse and took shelter from a summer rain. Old trees are rooted in our history. They slow time, connect generations, remind us that though we are temporary, we can linger.

People have always believed such trees have magic. In past times the massive beech at the corner of Waukazoo and Main in Northport would have attracted druids beneath its octopus limbs; the virgin white cedars in South Manitou's Valley of the Giants would have been home to pixies and sprites—and the giant of the giants, the North American champion white cedar, which, until it broke off at the trunk and died a few years ago measured more than eighty feet high and had a circumference of seventeen feet, would have been the palace of the leprechaun king.

They're growing scarce. That champion cedar was felled by gravity. An American elm said to have had a girth of more than twenty-seven feet (which likely would have made it the largest of its species in North America), was cut decades ago to make way for the Air Force radar station on the hill above Empire. Others fall to roads and housing developments, to disease and insects, to wind, ice, fire, and lightning. Like corporate employees they retire and are not replaced. They can't be replaced, not in our lifetime or our children's lifetimes. Money won't buy new ones. It's possible to purchase a tree a foot or fourteen inches across at the trunk and a crew will dig it up from one place and plant it wherever you want. But the job costs thousands of dollars and the probability of survival is low. And of course that isn't even a big tree.

Size is not the only measure of magic, of course. An ironwood in a field in rural Grand Traverse County measures about a foot across at the trunk and reaches a height of seventy-four feet—hardly a behemoth, yet it's the largest ironwood in the nation, and very, very old. But the biggest trees are the ones that seize our attention. They block the growth of other trees; they shelter and provide nests for squirrels, porcupines, opossums, raccoons,

and birds; they support tree houses and rope swings; kids climb into their lower branches and sit a while. To be considered truly old a tree must have germinated long before the invention of automobiles and electric lights— and perhaps before the first European set foot on the land—and they must have given shade to four or five generations of picnickers.

You can find them if you look. They hold court in the woods, are sequestered in fields, crown the tops of ridges. They're most impressive in open terrain, where they can spread to stately dimensions. In a woods a tree is shaped by its proximity to other trees, by rock and stream and hillslope, by its yearning for light and water in competition with the living things around it. Compare a typical woods maple with a yard maple or one that has grown to maturity in a meadow. A woods maple is tall and lean, with a long heft of trunk free of branches, and a slim pointed top. An openland maple has balance and symmetry; it has heft and bulk, with secondary trunks branching close to the ground and rising to a glorious crown of dense, full, rounded foliage. It looks the way a maple is supposed to look. It is, in the terminology of botanists, a specimen tree, an exemplar of its species. It's a survivor. It has become magnificent.

The centerpiece of our yard on Old Mission Peninsula is a massive sugar maple a century and a quarter old. Perhaps older. It measures more than four feet across at the stump and spans half the yard with limbs that would be big trees themselves if they grew from the ground. On a bright afternoon in October, when my son Nick was five years old, we threw a Nerf football back and forth beneath those branches. I tossed the ball high among them, into the lemon-colored foliage, and four or five leaves broke free and glided down. We ran after them, trying without success to catch them in our mouths, as if they were mayflies and we were trout. I threw the ball again and this time when leaves came down we caught them any way we could, clapping them between our palms, snatching them in our fists, trapping them with our arms against our chests.

That summer Nick had spent so much time with our Labrador retriever—hugging her while she licked his face, wrestling with her in the grass, using her for a pillow while he watched tv—that when he was damp with perspiration he gave off the scent of dog. His feral self had been

released. He was tanned brown, his fingernails were grubby, his hair was braided with twigs. He announced, "I don't eat broccoli because *my taste bugs* don't like it!" And, "Dad! I've got almost as much *fur on my legs* as you do!" His growing body filled him with fascination and pride and he was intoxicated with independence. Every day that summer he wanted to arm wrestle with me, to race me to the end of the driveway and back, to see who could throw a baseball the farthest. The morning of his fifth birthday he had run downstairs breathless, eyes big, and asked his mother, "Did I grow in the night?"

Now he shouted that we must chase leaves until we had captured a total of thirty-five (in the air! in the air! no pinning against shrubs! no trapping on the ground! no picking up the already fallen!), and whoever caught the most would be the champion. A leaf disengaged and fell, and Nick ran after it, arms reaching. It skidded through the air, and he missed. It dodged, and he missed again. It nose-dived to the ground, and he followed, his hands snatching air. He rolled over on the grass, laughing, and looked at me. We locked eyes.

The moment hung between us. It was palpable. It resonated like the afterhum of bells.

"You think you'll remember this?" I asked.

It was a strange question, more than a little greedy. I couldn't stop myself. The moment was so wonderful that I wanted to possess it, to stash it safely away. And I wanted Nick to possess it also.

"You mean forever and ever?"

"Forever and ever."

"Yes," he said with certainty, as if it was ridiculous to doubt it. Then a gust of wind came and more leaves fell, and Nick spun among them, laughing, trying to catch them all.

Time flies, even while old trees stand their ground. Our best moments drift past and we grab, but they're elusive. And sometimes they land in our hair and we don't even know it.

———————————————

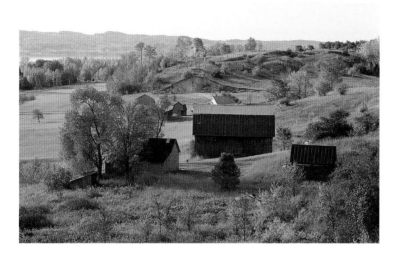

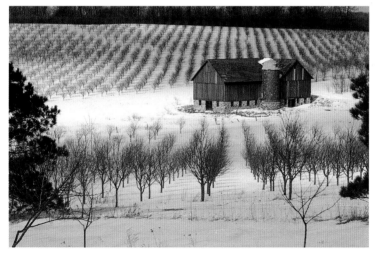

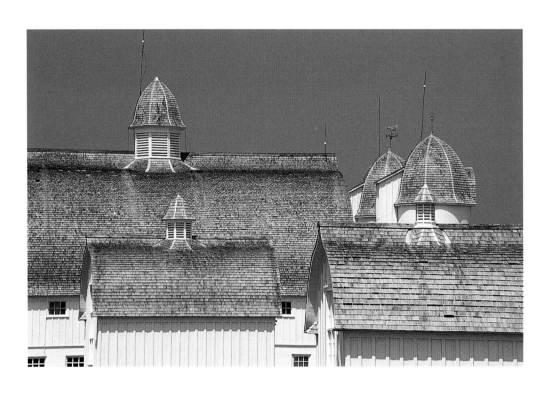

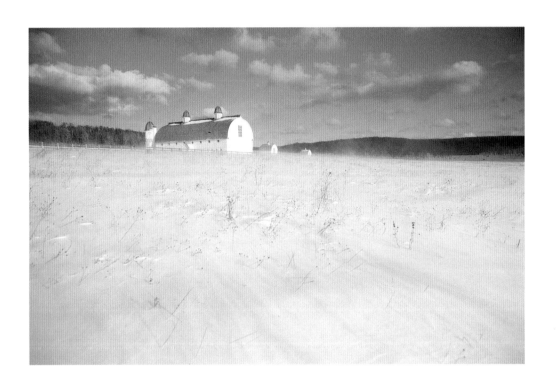

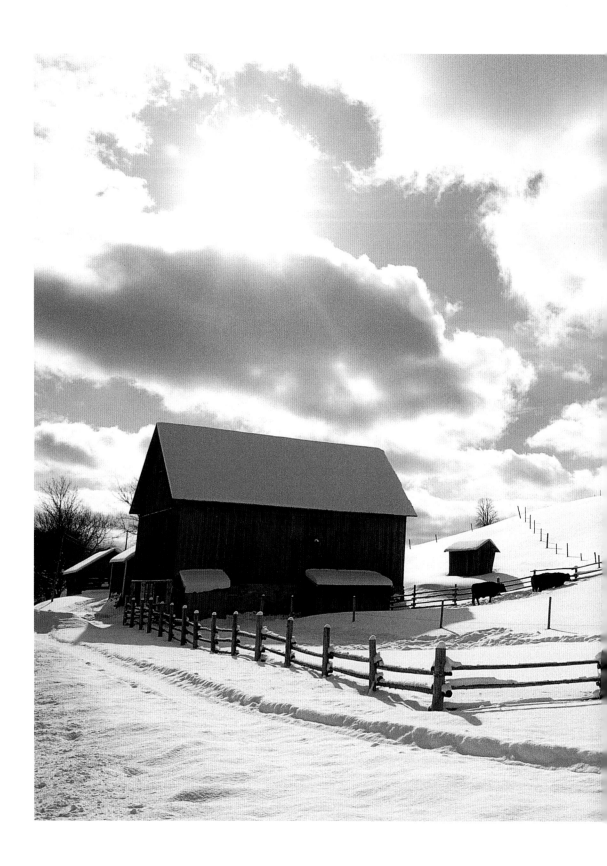

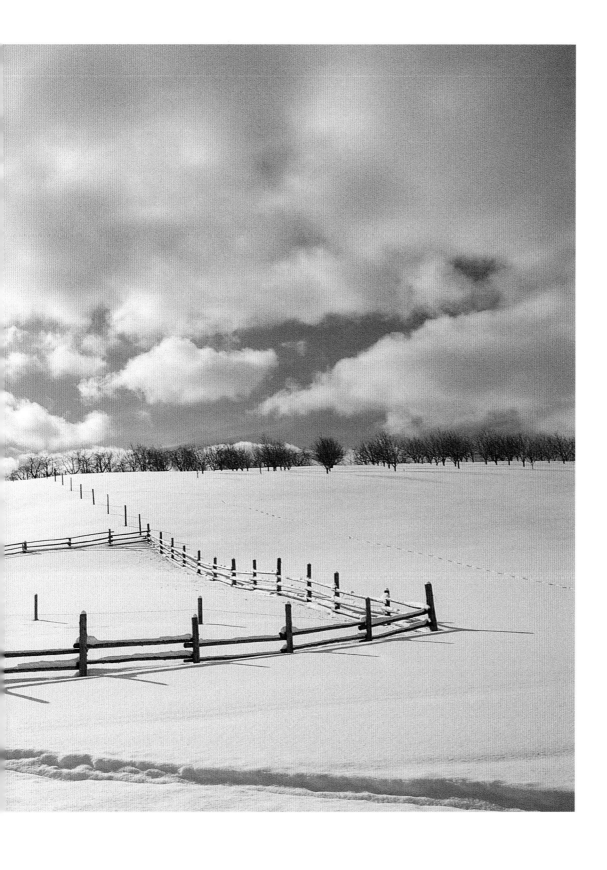

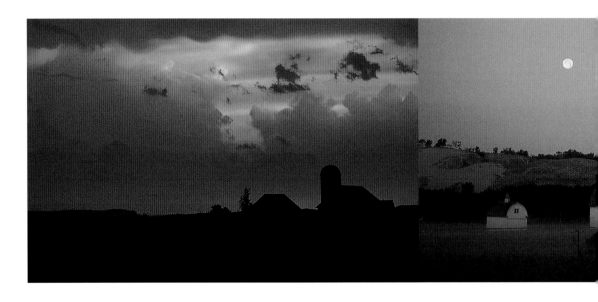

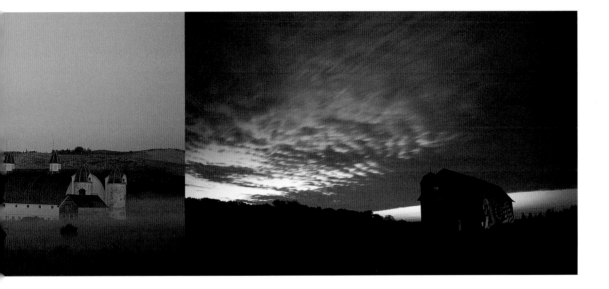

FARMING

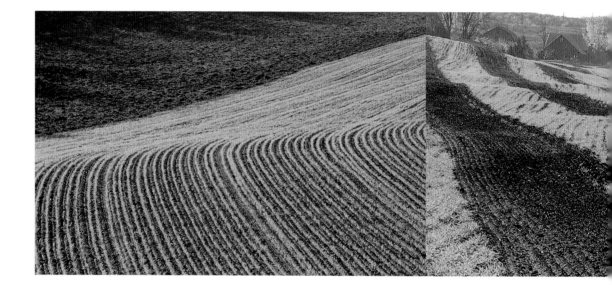

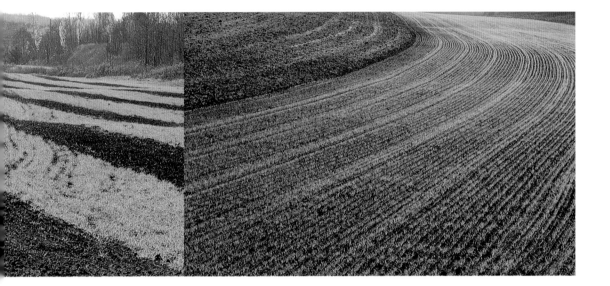

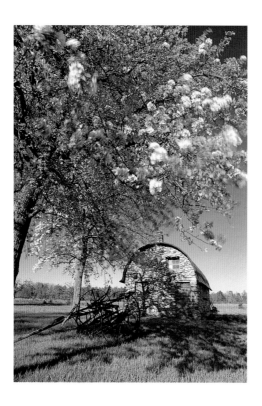 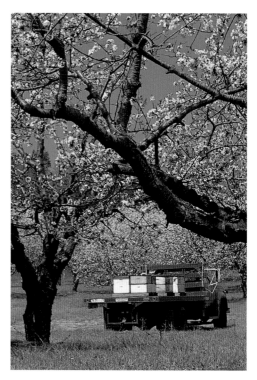

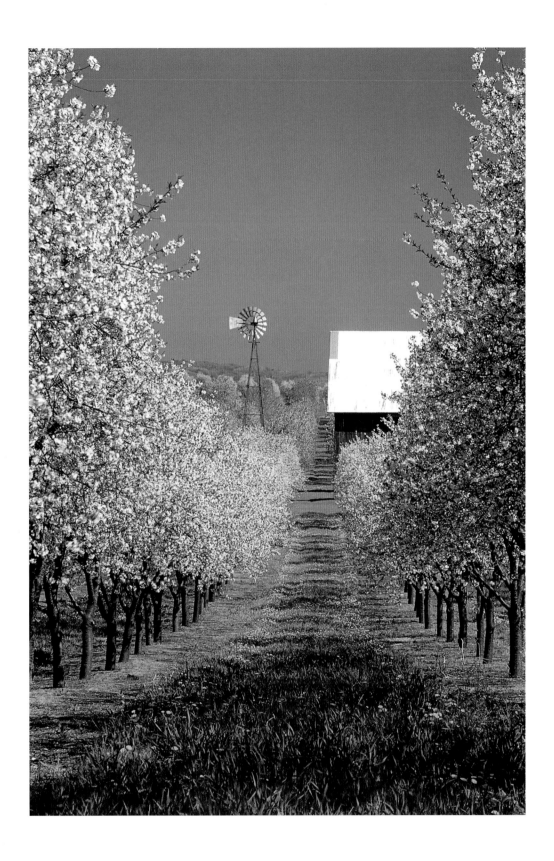

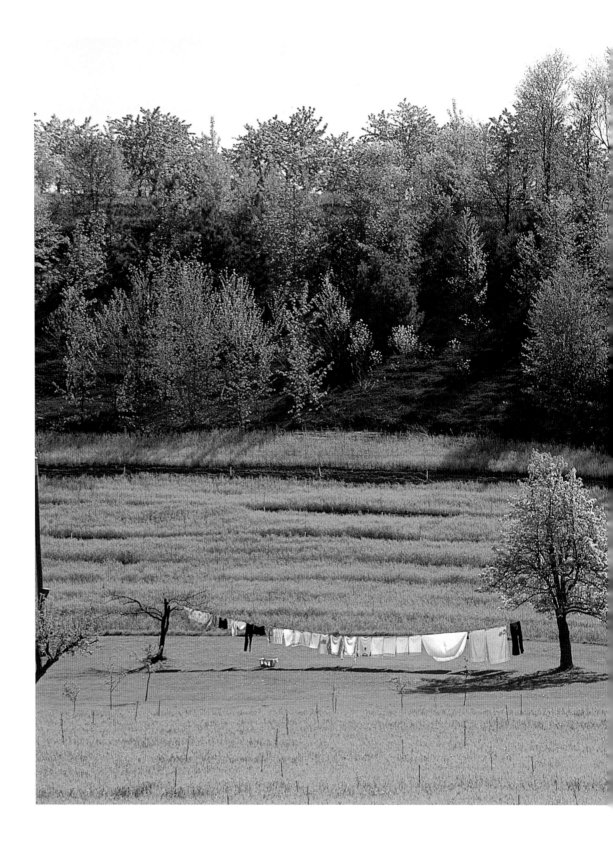

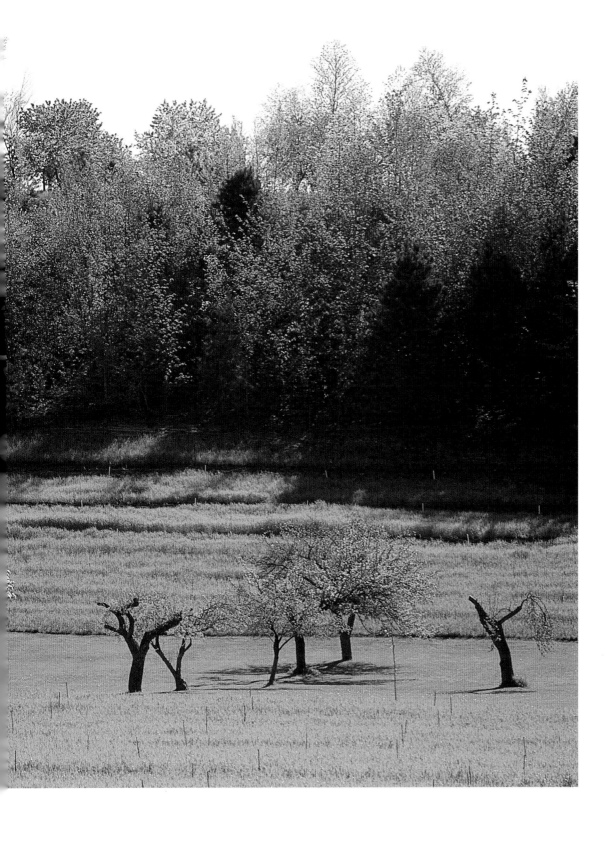

FARMING

77

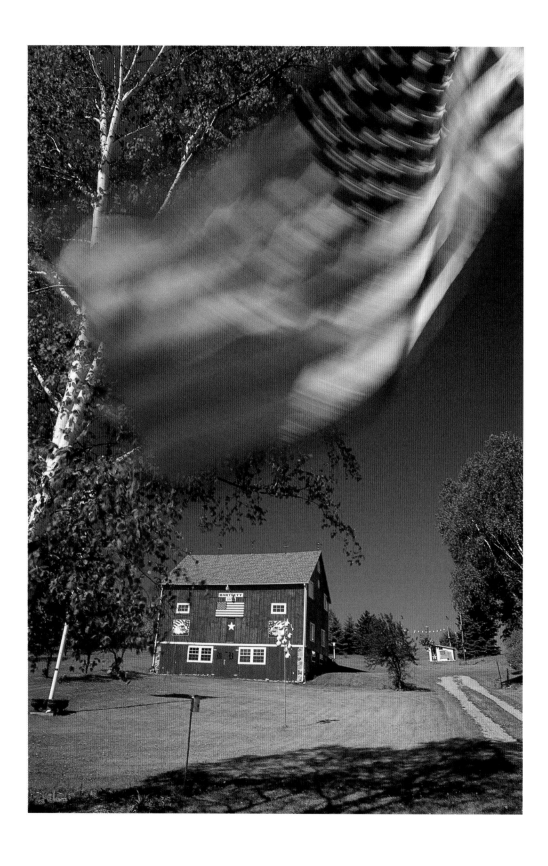

 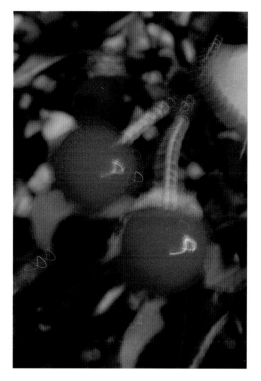

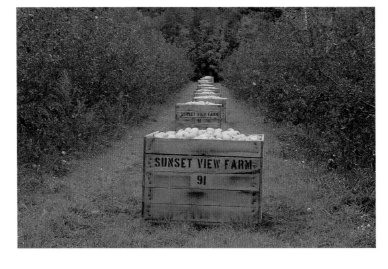

THOSE SUMMERS we were never free of the scent of tart cherries. They stuck to the seats of our jeans, got trapped in our cuffs, were crushed in the treads of the sneakers we wore all day in the orchard. Even in the evenings, after a shower and clean clothes, when my cousin Steve and I were ready to go out to meet the daughters of other orchardists, the house was filled with the fruity sweet-and-sour scent of our grandmother's pies and cobblers and preserves. It was the last thing we smelled when we fell asleep and the first thing we smelled when we woke. We worked from daylight until dark during the harvest, and even in our few hours of free time could not be rid of cherries.

Steve was the precocious son of a Flint, Michigan autoworker, and I admired him immensely. At night, lying awake talking in the creaking, musty, upstairs bedroom of the farmhouse, I learned that he, at fifteen, had already explored worlds I hardly knew existed. He had driven street racers and motorcycles, had gotten drunk on whiskey, had killed deer and trout out of season, had unhooked the brassieres of girls while making out in his father's car. Steve smoked cigarettes like James Dean, could double-clutch our grandfather's ancient and rattling farm truck and make it reach an unheard-of forty-five miles per hour on the dirt two-track through the orchard, and told jokes that left the older farm workers bent at their waists with laughter. He was tall, handsome as a billboard model, and supremely self-confident. He was everything I was not.

One night in the darkness of our room he told me he planned to someday marry Julia, a tall girl who lived on the farm adjacent to our grandparents'. In the evenings sometimes we walked past her father's orchard and chicken farm, with the long roosting house lit twenty-four hours behind its rows of dusty windows, and met Julia beneath the trees at a roadside picnic table. It was never clear why I went along, although I suspect that Julia, savvy to my cousin's worldliness, insisted upon it. One night she brought a friend, a pretty, big-boned, no-nonsense farm girl who outscaled me by at least five inches. Julia and Steve sat close together on one side of the picnic table whispering to one another, while Julia's friend and I sat apart on the other side watching the stars and trying not to look at each other. After a while, under pressure from Steve, I slid the length of the bench until my thigh bumped the girl's, causing her to flinch. "Recoil" is the word I mean. She stood, stepped to the other side of the table, and sat beside Julia.

We had Sundays off, though it was no great freedom, being stuck on the farm far out in the country. If it rained we often spent the day in the barn, feeding the horses apples and oats, enlarging the tunnels and secret rooms we had constructed in the bales of hay stacked to the rafters in the loft. Other days we took fishing rods and hiked to pothole lakes in the woods and fished out of leaky wooden boats left on the shores, or walked across the highway to Great-Aunt Lucy's and Great-Uncle John's house, the annex of Sleeping Bear Farms. Ours was the cherry farm, adjacent to the orchards; theirs, a half mile down M-72, was the headquarters for the maple syrup business, with a sugar shack out back and, nearby, the eighty acres of hardwoods where the sap was collected every spring. Under the trees in front of John and Lucy's was a roadside stand where everyone in the family took turns selling cherries, canned preserves, and jugs of maple syrup to motorists.

For something to do on our day off, Steve and I might hang around the stand for a while with Steve's sister, Sandy, and our cousins Jackie and Valerie, then visit Aunt Lucy in the house, and afterward go for a hike down the county road toward Glen Lake. Once Steve leaped over an embankment, rolled to the bottom to hide from an approaching car, and got tangled in barbed wire. He came up the bank bleeding from dozens of wounds. When we walked into Aunt Lucy's kitchen and she saw the blood running down his arms and soaking through his shirt, she raised her hands to her face and screamed, and Steve laughed. Another time, in answer to my dare, he urinated on the hot strand of an electric fence. He laughed about that too, but not until later.

Steve enjoyed life on the farm, but didn't like the isolation. He was often bored and restless. He wanted things to happen, and when they wouldn't happen on their own he manufactured them. On an afternoon when Grandpa was away, a carload of tourists drove into the orchard, as often happened, and stepped out to watch us work. Steve approached them slackjawed and muttering like a farmer's idiot son who was usually kept locked in the attic, and stood uncomfortably close to a boy a few years younger than we. When the boy edged away, Steve moved even closer and laid his head on his shoulder, causing me to laugh so hard that I ran yelping through the trees, the other idiot son. On a Sunday afternoon when we had nothing to do, he might set to work in the toolshed resolutely destroy-ing an antique butter churn with a ballpeen hammer. Or, to my horror, he

would build small, controlled, but potentially catastrophic fires on the floor of our hideout in the hayloft, tormenting me by igniting lines of straw fuses and letting them burn slowly toward the bales. One Sunday while we were killing time in the barn, he noticed that one of the stallions kept tossing his head, trying to clear the forelock from his eyes. The horse was Grandpa's prize palomino, which he rode proudly every year at the head of the cherry parade in Traverse City. The forelock was thick and blond, and flowed nearly to the tip of the stallion's nose. Steve clipped off a few inches, straight across, like bangs, but the cut went slightly askew. He trimmed some more to even it out, but now it was crooked the other way. When he finally stepped back from his work the forelock was hacked to the nub, and the horse looked ashamed and ridiculous, like a farm kid after his summer buzz cut. That evening, while watching television in the living room, we heard Grandpa shout from the barn. The barn was a long way from the living room, but we heard him clearly. He shouted a single word that ended in a howl: *Steeeeeeeve!*

···❮❁❯···

I liked the work. I liked sweating in the sun, every inch of my skin alive under my teeshirt and jeans, pulling the drenched shirt over my head and flinging it under a tree and feeling the sweat turn cool with evaporation, my summer muscles taut, my bones young and strong. I liked the shock of cold water when I plunged my head into a fresh cooling tank, that white-painted steel cube four by four by four feet resting on forks on the front of the tractor and filled to the top with clear blue well-water, ready to receive cherries. I liked the hot wind in my face and the sun on my back, of being every moment half a breath away from laughing out loud at nothing whatsoever, wanting to leap straight into the air, high above the orchard, and take long greedy flapping strokes across the sky—and being absolutely certain I was capable of it. I whipped a cherry at Steve and it struck his back with a satisfying wet smack and left a bright stain like a wound. I roared in triumph. Nobody was more alive than I, and I knew that I would feel exactly the same every day for the rest of my life. Rest of my life? Forever.

I liked the trees with their limbs hanging heavy with cherries, some so heavily laden that branches split from the trunk and fell, the cherries spilling across the ground. I liked the thump and rumble of the machinery, the pumping blue exhaust, the power in my hands when I

84

CHERRIES

gripped the controls and pulled levers and their hydraulic certainty multiplied my strength a thousand times.

I liked making the trees shake like ragdolls and causing the cherries—brilliant, gleaming, each a scarlet drop of my grandfather's determination to squeeze money from the earth—fling from the tree and fall, a torrent of scarlet drumming on the tarps and funneling heaped onto the conveyor belt at the bottom, then pouring in a steady thick red waterfall over the lip of the conveyor into the holding tank. As the tank filled, the cherries displaced water, sloshing it over the sides as Grandpa moved the tractor in lurches from tree to tree behind the shakers, leaving the dirt mud-stepped, like the tracks of a giant just out of the shower.

Two shakers worked in concert, one on each side of a tree, each an engine-driven, wheeled machine that conveyed both the large framed tarp and the hydraulic shaker arm. One year, Steve operated one shaker and I operated the other. Other years our cousin Keith was in charge of one, or Steve's brother Don or my brother Rick took turns with them. We were a crew of mostly family, but always with a few local men hired to help (and they were the best workers, the most knowledgeable about the machinery, the handiest with tools and repairs, the kinds of men who were happiest when they were bent over an engine with their hands buried inside), but we were family and it was a family business after all. We expected it to remain in the family forever.

I liked the endless procession of trees, spaced identically, with the ground between the rows bare where tractors and pickups rode all summer and with high grass growing thick and cool under the branches; and how the rows were so straight that when I lined up the trunks I saw only one trunk, and extended so far—a quarter mile? a half mile?—that as I worked I slipped into a haze of repetition as comfortable as a daydream. I drove the rig slowly forward while walking beside it with my hands on the controls, stopping beside the next tree, pulling the lever that lowered the broad winglike tarp until it nudged the base of the trunk, swinging the shaker arm into position, clamping the rubber-cushioned claw on a secondary trunk, clamping tighter so the bark would not tear, and tighter still, then pulling the shaker lever and releasing a machine-gun burst of tremors—*whump-whump-whump-whump*—the arm jumping as fast as a jack-hammer, the tree shuddering, the cherries falling thunderously; another burst—*whump-whump-whump*—and a fall less thunderous than the first; one more burst—

whump-whump; then releasing the claw, swinging the arm away, raising the tarp, guiding the machine to the next tree, and doing it again.

At the end of each row we broke routine and maneuvered the clumsy rigs around—backward, forward, backward, forward—and aligned against the first tree of the new row. We operated the machines from dawn until dark, stopping only to eat lunch and dinner (or dinner and supper in the parlance of the farm) and to gas and oil the engines, finally stopping for good only because darkness fell at ten. Sometimes even darkness wouldn't stop us, especially near the end of the harvest, when the fruit was becoming too ripe and every tank of cherries could be the one that earned a profit. Then we worked for two or three hours into the night, invigorated by cool air and novelty. Spotlights on the shakers and the headlight of the tractor threw the trees into shadows as big as houses and made the cherries black.

Every day at lunch and at dinner on the evenings when we worked late, my grandmother drove the old farm truck to the orchard and parked next to the rigs. We hit the kill buttons and for a moment the silence was strange. Then we heard birds singing and cicadas buzzing and Grandpa groaning as he climbed down from the seat of his tractor, and the world was as it should be again. From the back of the truck we unloaded picnic baskets and sweating jars of lemonade and iced tea with the teabags still floating among the ice cubes and carried them beneath a tree and sat with our backs against the trunk and our legs out like wagon spokes. Grandma poured tea and lemonade in glasses while we opened the baskets and passed out sandwiches—ham and cheese with mustard or tuna salad or chicken salad with lettuce and mayo on homemade bread cut thick as books—and hunks of cheddar and sweet pickles and dill pickles and carrot sticks and celery sticks and whole tomatoes we ate like peaches, letting the juice run down our chins, and huge wedges of apple pie we gripped with both hands, a quarter of a pie for each of us.

Grandpa told stories and laughed while we ate, but he hated to stop, even for meals. Any delay cost money. In a few more days the fruit might be so ripe that it bruised when it fell. Or a storm might come and knock it from the trees. The value of the cherries varied from day to day, from one tank to the next, depending upon market forces and the judgment of the state inspectors who took random samples from every tankful and measured them for size and counted them for bruises and disease. All of my grandfather's labor—clearing the land and planting the thousands of saplings

in rows he laid out with a surveyor's transit; nurturing them for seven years until they began to bear fruit; watering and fertilizing them, protecting their buds from deer and their bark from field mice and voles and rabbits; standing guard every spring against late frosts when the buds were vulnerable, and if the temperature fell below freezing tending smudge fires of discarded tires and setting up large fans run by salvaged engines to keep air circulating and frost from settling; pruning the trees every winter; spraying them a half dozen times a year against insects and disease; maintaining and repairing the shakers, tractors, and trucks; pouring cement for the cooling pads and sinking new wells for the water they required—all the labor of every season of every year for decades was brought to fruition during those three weeks in July when the cherries were ripe and had to be shaken from the trees and hauled to the cannery and sold. No wonder he was up before daylight, and hated to stop.

　　　　The years blur. I started working on the farm when I was eight or nine and the cherries were still picked by hand. Families of migrant workers had been coming to the farm for years, arriving from Mexico by way of Texas, a dozen or fifteen people in a stake-truck heaped with belongings, two or three trucks in caravan, with everyone grinning and waving as they pulled into the drive a week before harvest. They stayed in temporary housing in the tractor shed where machinery was stored in winter, in rooms partitioned with two-by-fours and sheets of cardboard, with rugs laid on the concrete floor, and secondhand beds, dressers, chairs, and lamps arranged neatly. Entire families worked together in the orchard, everyone from five to eighty pitching in. We'd ride up to the hill in trucks in the cool early morning, with dew hanging so heavy on the trees that you were soaked just brushing against them, and set up wooden stepladders—eight-, ten-, twelve-, and fourteen-footers. We picked each branch of a tree from its base to its tip, tickling the cherries loose with our fingers and letting them drop into galvanized buckets hanging from harnesses over our shoulders. When the buckets were full we climbed down the ladders and emptied them into wooden lugs marked with our initials, filling them level at the top and adding them to stacks of other lugs waiting to be hauled by truck to the cannery. At the end of the day, we tallied the number of lugs we had filled, and at the end of the week got paid an amount that varied with the value of that year's harvest. When the harvest was abundant the price was low, as little as twenty-five cents per lug; when the cherries were scarce, decimated

by frost, drought, wind, or birds, a lug could bring a dollar or a dollar and a quarter. The best workers picked twenty or twenty-five a day. My cousins and brother and I would each pick twelve one day, ten the next, six the next. By the end of the harvest we spent more time throwing cherries and chasing each other among the trees than we did picking. But we were very young.

I worked at the farm most summers until I was sixteen and Steve was seventeen. That year he got a job at the Buick plant in Flint and stayed home. I found work in Traverse City and spent the summer at the lake with my parents.

By then the farm was making a profit. Grandpa and Grandma bought new appliances and a fifth-wheel trailer they took to Florida for the winter. Elaine would have liked to travel more. She loved to see new places and meet new people and visit relatives scattered around the country. Clair was uncomfortable away from home, refused to eat unfamiliar foods, hated driving in city traffic. But it looked like he might consider someday retiring to someplace warm.

None of us expected it to end so abruptly. Grandpa least of all. The cancer was advanced; he had little warning.

Uncle John died shortly before my grandfather and Aunt Lucy moved away to be near her children. My father, Uncle Jack, Aunt Joyce, Steve—I was sure someone in the family would take over the farm. But they all had other plans. They wanted to soar and the farm was filled with tethers. I was eighteen, too young and too ignorant to consider it myself. I hadn't been very attentive while working for Grandpa, and he was not a gifted teacher. He didn't plan to die so soon and was probably ambivalent about sharing the knowledge of a lifetime with his smartass grandsons.

For a few years my grandmother leased the orchard to neighboring farmers and rented the house to tenants. Finally, someone approached her with an offer and she sold everything, all of it, too hastily, for less than it was worth.

It pains me still, a quarter-century later, to drive past and see a strange name on the mailbox.

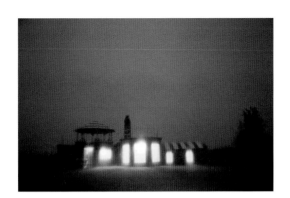

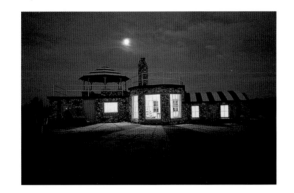

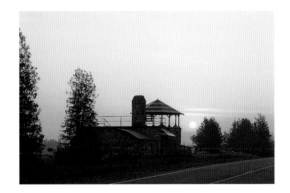

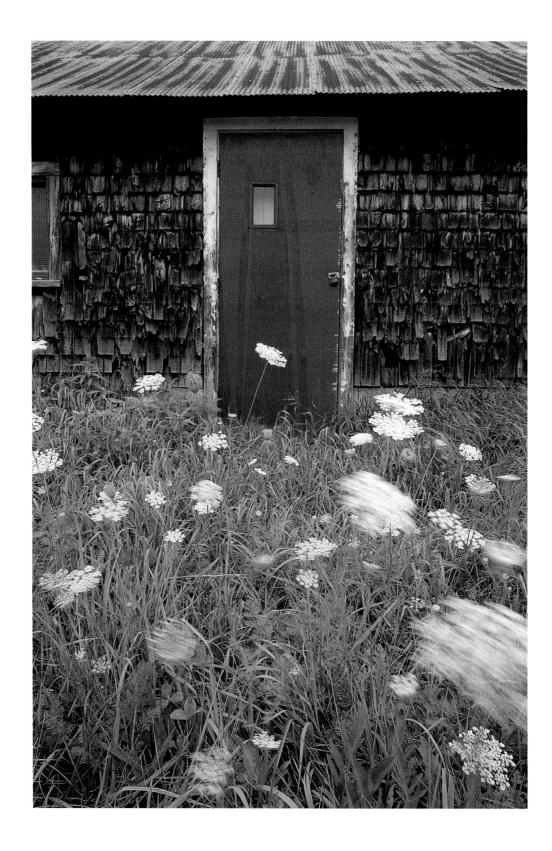

DAYTRIPPING

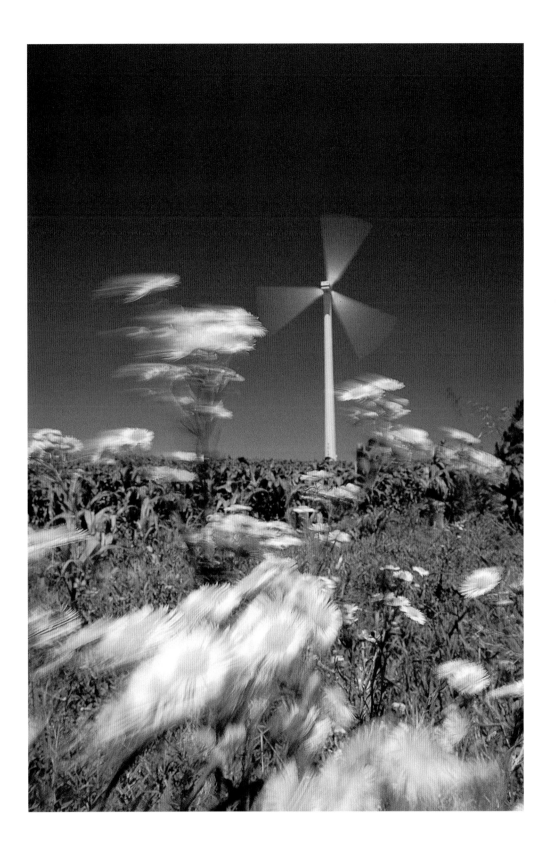

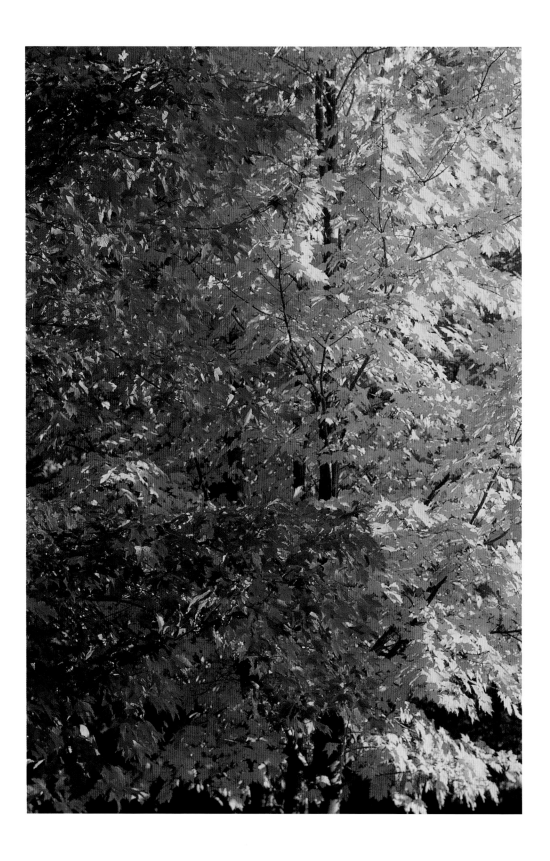

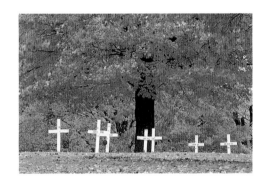

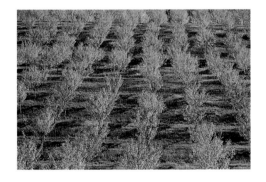

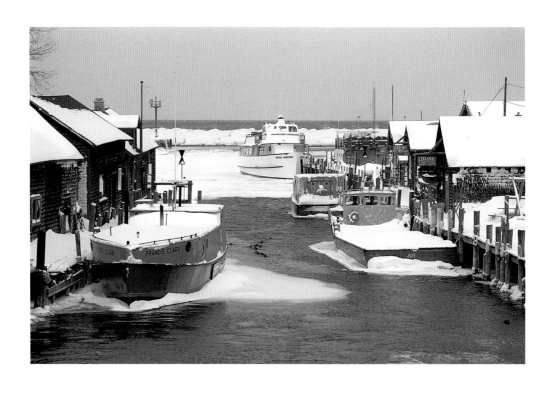

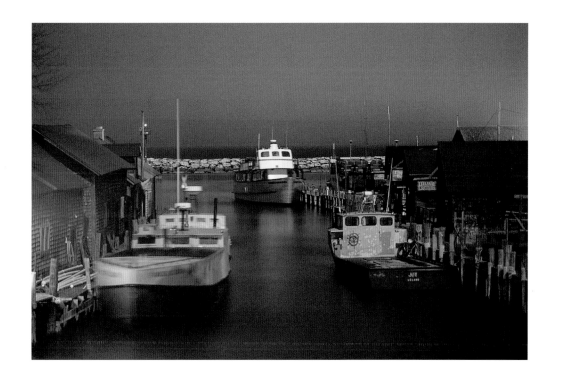

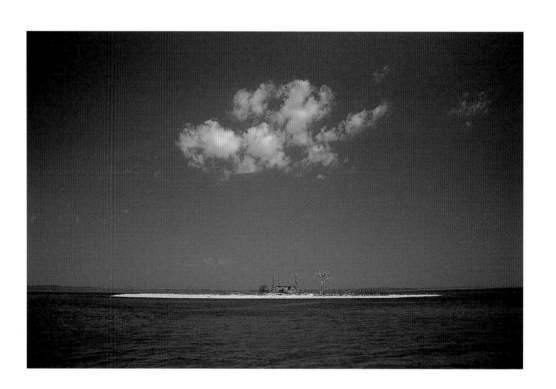

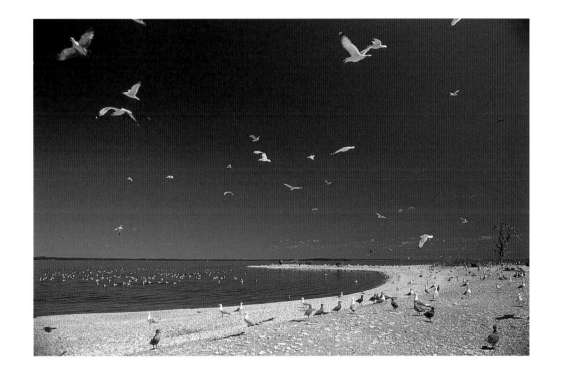

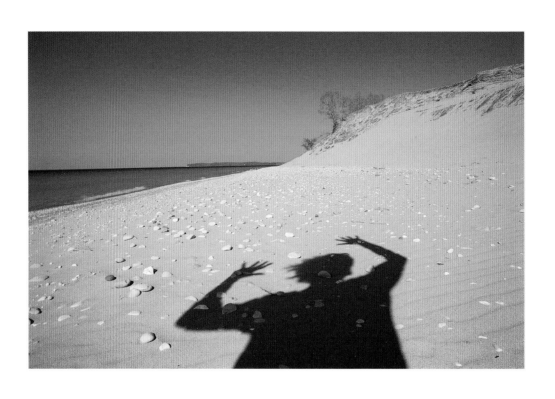

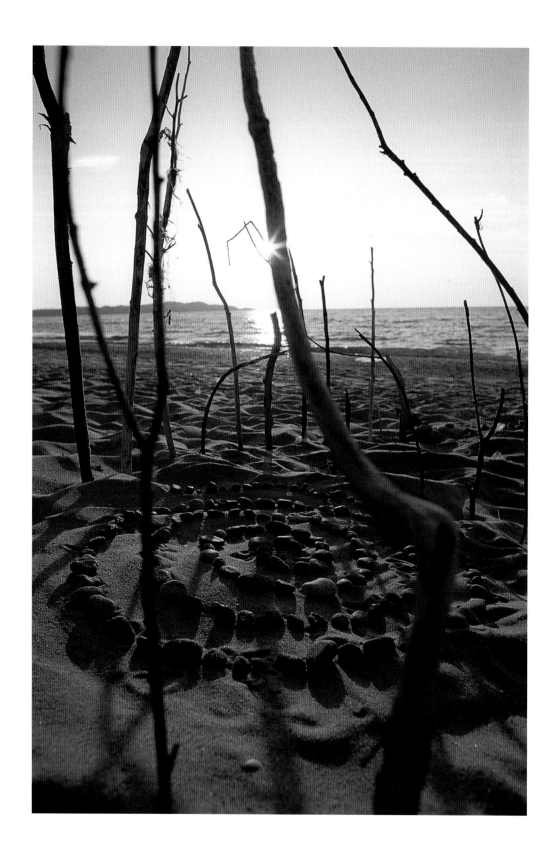

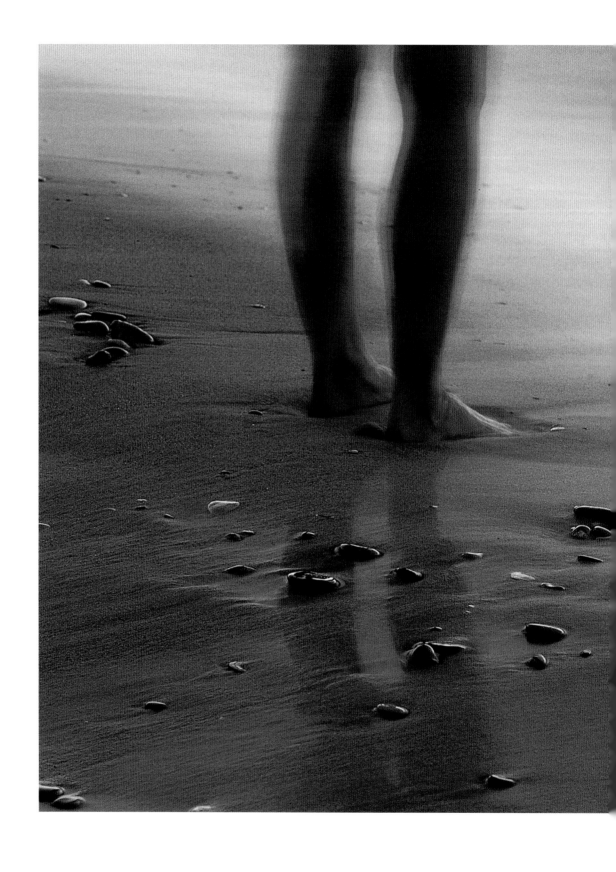

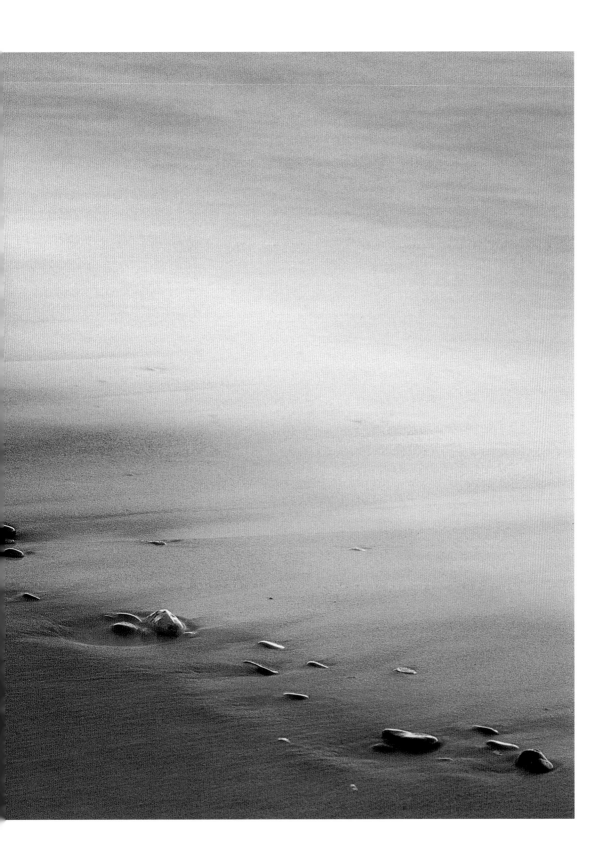

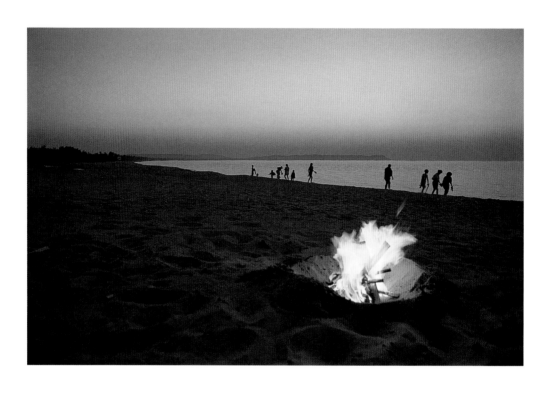

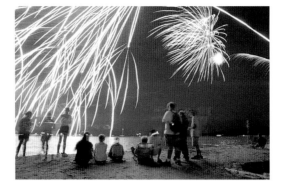

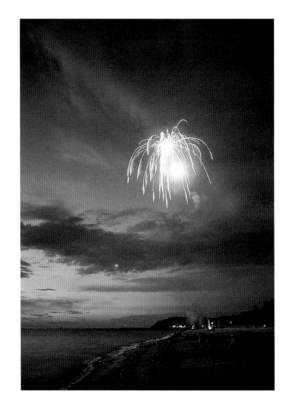

IT'S ALWAYS A SURPRISE. You forget.
One morning you awake and find
cold hunkering in every corner of the

house. You step outside and there, you remember now: A day of forty
degrees is altogether different than a day of sixty. From the north comes
the first autumn wind, a sweater-and-jacket wind fresh from Canada,
pushing dark clouds heavy with freight. The sun breaks through, but it's a
brittle, brazen light that warms little. The season is changing. There'll be
no stopping it.

Cold weather reminds us how serious the world can be. How
serious, harsh, and indifferent. Indifference is tough on us; it contradicts any
comforting notions we might have about being the preeminent inhabitants
of a benign universe. But a measure of seriousness is welcome, like being
talked to as an adult when you were a child. After the frivolous amusements
of summer it feels good to get serious about winter. It's solemn business.
Gail teases me when I spend all afternoon moving firewood from the outside
ricks to the garage, and split a month's worth of kindling besides. Firewood
for us is not essential; our house is heated with fuel oil, and the fireplace
provides mostly atmosphere and entertainment. But I've seen broken power
lines and frozen pipes and an oil furnace that failed during a storm, and I
know the fireplace can be a line of defense. After the wood is stacked,
I gather black walnuts from the yard and carry them to the basement in a
cardboard box. Just in case.

Cold has a taste, like spring water and iron nails, with a hint
of beechnut. It's cleansing and bracing. It vitalizes the taste buds. Inhale it
deeply and you feel its weight burning in your nostrils and at the back
of your throat. It tightens the skin of your face like a drumhead and makes it
receptive to the touch of breeze and mist. When you have forgotten the
feel of it, the first cold wind of the season is like a slap on the cheek—
reminding you, energizing you.

Ah, yes. You were half asleep all summer, and now it's time to
wake up. Time to stack wood.

———————————————————

FOR A FEW YEARS after college I helped build condominiums on the hills above Glen Arbor. They were architecturally complex buildings, three stories high, stepping up the ridges like lines of vertebrae. My mother grew up playing on those hills, and had taken me there when I was a child to hike and hunt morels, so I was distressed to see the trees cleared and the roads built. But jobs were scarce, and this was steady work.

That year my wife and I were staying in a house on Silver Lake. We would have to move in the spring, when the owners returned from Florida, but it was a nice place for the short term and the rent was cheap. Gail stayed home with the baby every day while I commuted the thirty miles to Glen Arbor, which was fine in the fall when she could take him for walks in the stroller, but as the winter progressed it got hard for her, being stuck home all day without a car. Our old Datsun hated cold weather. When winter arrived I would light charcoal in a garbage-can lid every morning and slide it under the oil pan to heat the engine enough to start it. If it failed to start after a few cranks, the battery would go dead, and I would miss a day of work. When it did start, I'd spend ten minutes fluttering the accelerator and adjusting the hand choke before it ran smoothly enough to try putting it in gear. Often it would stall. Finally, in January, it would stall more or less permanently, and I would be forced to leave it in the driveway, where it would be entombed by the county plow.

Paul Maurer, my employer, would loan me a Volkswagen Beetle he'd owned since he was a student. It ran dependably and had a good eight-track stereo system, but the accelerator spring was broken and like all VW's it had virtually no windshield defroster. I would drive it for several weeks, until Gail and I saved enough money to have the Datsun towed to a garage.

Paul had rigged a length of string to the accelerator pedal and showed me how to hold it like reins in my right hand while I drove. To shift gears I would pull on the string to decelerate, depress the clutch pedal with my left foot, then slam the floor shifter from first to second or second to third, let up on the clutch, and accelerate again with my right foot. It took some practice. When I got good at it, I felt like one of those novelty musicians who plays six instruments at once. Between gears I would punch the track-changer on the stereo and scrape frost from the inside of the windshield with a plastic spatula I found in the glove compartment.

But all that would be later, when we were deep into winter. In November, before the snows came, some of us on the construction crew had only a vague idea of what was ahead. At lunch breaks we sat around propane heaters and talked about the building boom in Houston and debated whether it was worth renting a U-Haul trailer and moving down there, assuming our vehicles could get that far. The old-timers told the new guys like me stories about the months to come—how we would be given the option of not working when the temperature was below ten degrees, but would work anyway because nobody wanted to lose the eight hours; how we would have to spend the first hour of every morning shoveling snow off the deck and breaking ice that froze the piles of lumber into blocks; how we would have to rub bag balm on our hands to keep them from cracking and bleeding, but there was nothing we could do about our lips. We would hear about frostbite and no feeling in fingers and toes; about Jerry Weese's soggy stub of a cigar freezing to his beard; about Andy Willy touching his tongue to a piece of steel wind-bracing, and his brother John setting him free by pouring hot coffee over it; about the roofer who stepped on ice and slid down the roof and would have fallen three stories if he hadn't slammed his hammer through the plywood at the last possible moment and hung with his legs kicking in space until somebody could get to him from above—and how he went right back to work, without comment, as if nothing unusual had happened.

What the old-timers didn't tell us, but we would learn on our own, was that it was all in a day's work, that cold and snow were more of an inconvenience than a hardship, that if you invested in a pair of Sorel boots and a stocking cap to wear under your hardhat and a sweatshirt with a hood to wear over it and always had an extra pair of dry gloves in your pocket and kept moving, but not so fast that you worked up a sweat, you'd be fine, the hours would pass, the buildings would get built. And there was pride in it. By spring we would all be veterans.

But, again, that was yet to come. The day I'm remembering was in November, when a dozen of us were framing walls on the third floor. From where we stood we could look out over the treetops and see North Manitou and all of the lake beyond it. The wind was in our faces, harsh and cold from the northwest, and seemed to be dragging winter along with it. Puddles on the road had frozen dry. A few leaves still rattled in the trees.

We heard noises in the distance, like dogs barking, and suddenly Canada geese started coming over the hill from the lake. They passed twenty

feet above us, each bird huge against that low sky, so close to us we could have thrown our hats and hit them. As they went over they swiveled their heads to look down at us and veered a little, as if they expected us to start shooting, and the tone of their honking changed from conversational to alarmed. Six, eight, ten, passed in a ragged skein, disappearing beyond the trees.

All work stopped. Saws whined to silence, hammers hung suspended. Everyone watched, even those who had never shown interest in wild things. Twelve, fifteen, twenty, we lost count, the two branches of the skein diverging as they went over, each goose swiveling its head to look down, passing one after another out of sight.

I glanced at the men on the floor around me. All of them, young and old, veterans and greenhorns, the whole ragged crew in their worn Carharts and insulated boots patched with duct tape—all of them stood motionless, heads upturned, watching. I was green, but not that green. I knew every damned one of us was thinking the same thoughts.

Wings. Flight. South.

But not for me.

{ *Winter Thunder* } WINTER THUNDERSTORMS are rare this far north. It takes rising heat, and snow doesn't give off much of it.

But the temperature today is sixty-five degrees at noon, the highest ever noted for February 24, and thunder rumbles around the shore of Good Harbor Bay. Because of the general grayness of the sky and the dampness of the air it is impossible to tell where the thunder originates. It rolls from one end of the sky to the other, or everywhere at once.

Then I see a flash to the west, in the gap in the hills behind Pyramid Point. As I watch, a freshening wind comes, ruffling the surface of the bay and bringing color to the water, subtle shades of green close to shore and blue farther out. The breeze reaches me; it is cold, refrigerated from its passage over the water. Rain drifts down across the bay, washing the bluffs white.

It is the slowest storm I have ever watched. Every few minutes a stroke of lightning lances earthward, stabbing hills. I count one-Mississippi, two-Mississippi, three-Mississippi, until, at the count of fifteen, thunder sounds. Three miles. A minute later there's another flash, I count, hear thunder—and it is three miles again. The storm is approaching, but at a stroll.

Then lightning begins to strike water, and the storm makes progress at last. A wall of rain walks up the beach toward me. Heavy drops fall, raise spouts of sand a half inch in the air, and leave tiny craters. When the intervals between lightning and thunder grow brief, I retreat to the house.

Inside, I stand at the window and watch. Rain streaks the glass and obscures the view, then falls so hard I can't see the lake. For a few moments, pellets of hail hop around on the boards of the deck as if its surface is too hot to bear. Lightning flashes in a general way, and thunder unfurls across a mile of air. The storm rumbles slowly past, its intentions serious, but the machinery rusty.

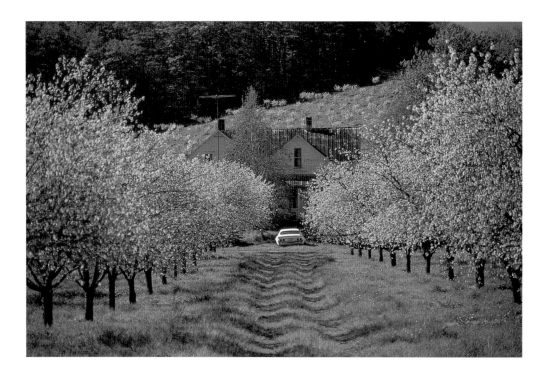

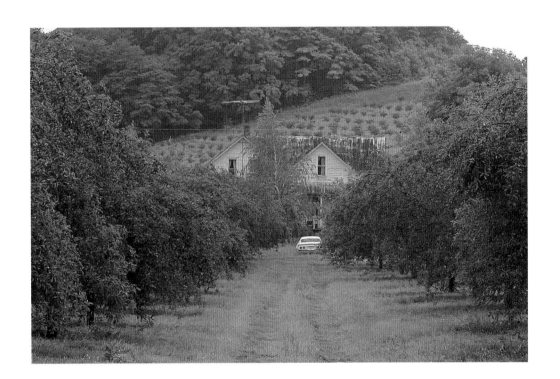

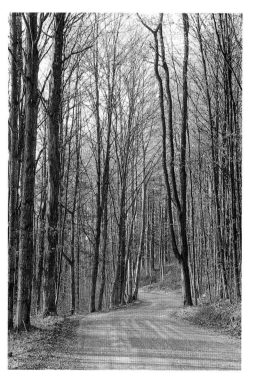
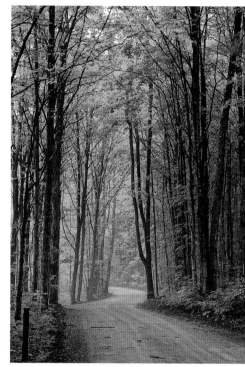

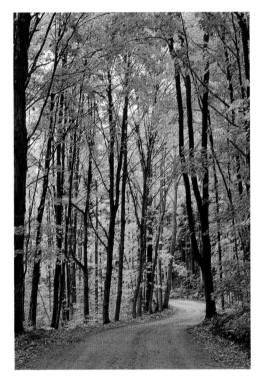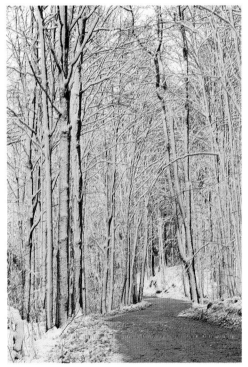

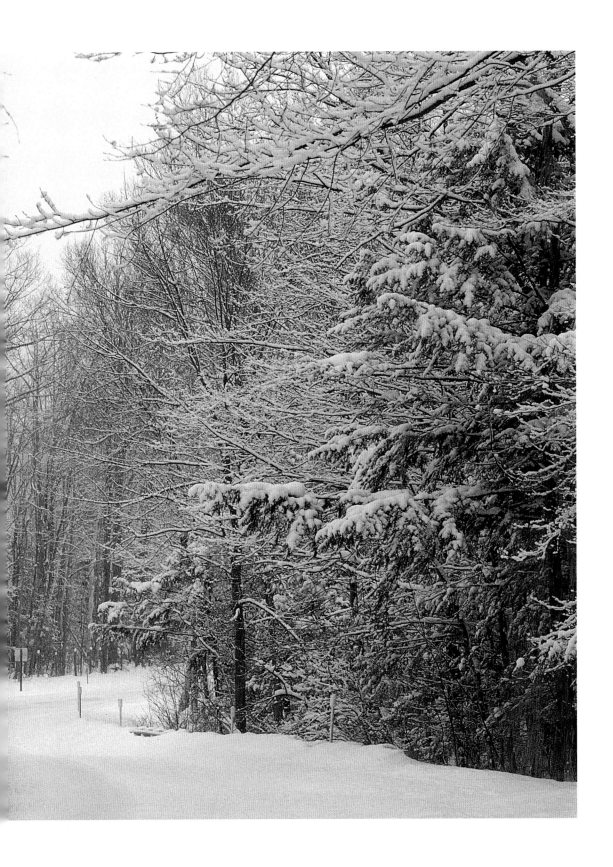

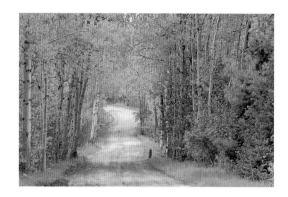

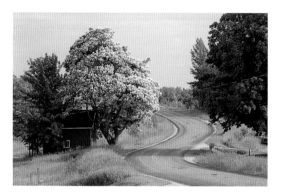

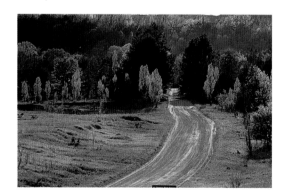

ROADSCAPES

123

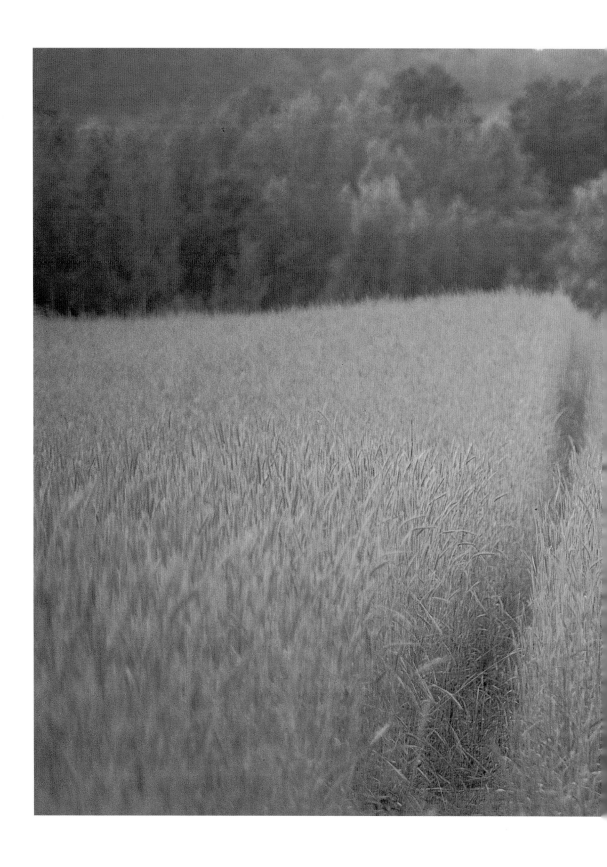

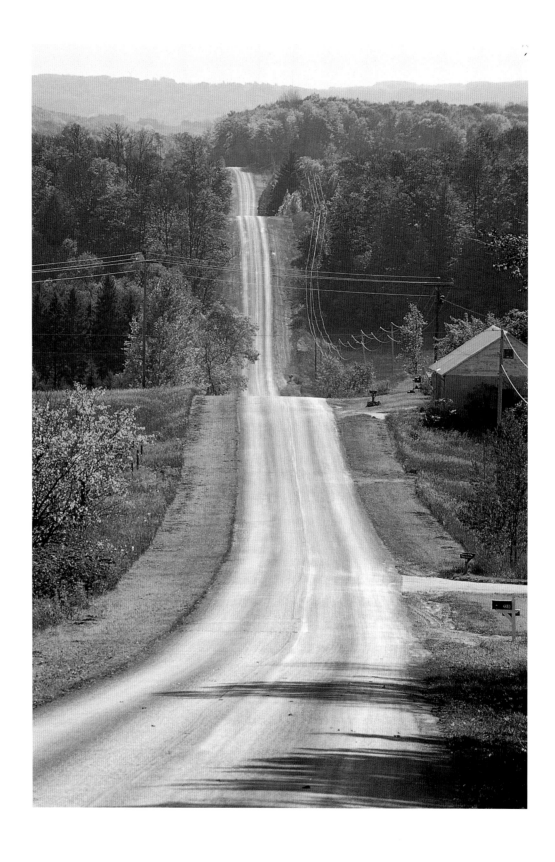

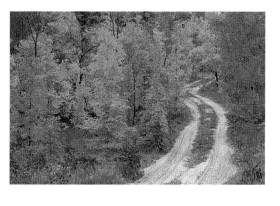

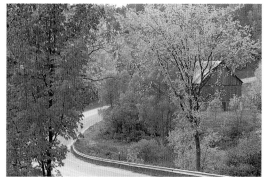

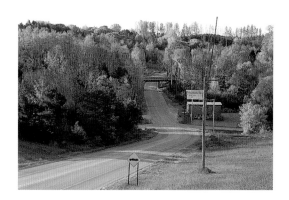

{ *Summer Work* } IT'S HARD TO REMEMBER NOW, with the water at a forty-year low, but in the early 1970s the Great Lakes were dangerously high. Up and down the shore, whenever waves came up, houses broke loose and slid into the water. In Chicago a storm surge flooded the Loop and set yachts adrift in city parks. Property owners all around the lakes were desperate for ways to protect their beaches.

I was looking for summer work, and a classified ad in the newspaper sounded perfect. It was placed by a college student I'll call Stan, who had a plan for halting erosion on the beach and needed manual laborers. He hired me, but with misgivings. "Kinda skinny," he said, when we met for the first time.

Stan's plan was to build breakwalls that would jut into the lake and interrupt the longshore currents. The theory was that waves striking a breakwall would drop their load of suspended sand and it would eddy behind the wall and extend the beach.

The theory was good, but it had a shortcoming. The sand deposited behind each wall was stolen from the beach in front of it. Stan didn't see that as a problem. It meant that wherever we installed a breakwall, the adjacent beach would need one also. Job security.

We built the breakwalls from rough-sawn poplar planks and cedar pilings cut at a local mill and delivered to the beach in Empire. We unloaded them from a truck, then humped them by hand down to the water's edge. A lot of trial and error was involved in the construction. First, we sank cedar pilings individually, two of us struggling to hold them upright against our shoulders—they were twelve feet long and heavy—with the waves surging against us and sometimes breaking over the tops of our chest waders, while Stan aimed a jet of water against the base of the piling and blew sand and gravel away. The jet was powered by a portable pump with a gasoline engine. It had a short intake hose for sucking water from the lake and a longer hose with a nozzle on the end for blowing it back out. The jet it produced was powerful enough to fold you in half if it struck you in the stomach, and could launch a fountain a hundred feet into the air.

When the work went well, Stan directed the jet into the lake bottom and the piling settled steadily, two or three inches at a time. But the work rarely went smoothly. We kept running into rocks too big to dislodge

and had to use steel bars and sledgehammers to shatter them or pry them aside. In some places the bottom was nothing but rocks.

After we set the first two pilings, we discovered that we could not nail the planks to them because it was impossible to swing a hammer through the water. We built the next one on the beach, laying six two-by-eight planks—each two inches thick and sixteen feet long—on pilings and nailing them together with spikes. The finished breakwall looked like an unpainted billboard tipped over in the sand, and was so heavy that we used all our strength just dragging it to the water. Once there we found it was impossible to stand the wall upright, let alone hold it steady long enough to jet the sand away and settle the pilings into the bottom. After much complaining about profit margins, Stan hired two more guys to help.

We made it work. By the end of the summer we had built a couple dozen of them. They stuck out from the shore like rows of stout suburban fences, and already the sand was collecting behind them, giving the beach a scalloped look that seemed like good defense against the lake. The property owners were pleased, and Stan made enough money after expenses to buy a used Volvo to take back to school. He asked if I wanted to work for him the next summer, and I said I didn't think so.

All winter, every time there was a storm, I imagined waves and ice slamming against the shore. In April I drove to Empire to see how the breakwalls had held up.

Gone. Not a trace. I heard later that Stan decided to spend the summer in Ann Arbor.

———

{ *Leland Blues* }

AT A BOOKSTORE READING, the poet Gary Winans, who lives in Seattle but has spent many summers in Leelanau, mentioned something he called Leland blues. I assumed he meant a state of mind, or the subtle visual aura of the place—the way the lakes cast the village in distinctive light, much like pines paint Glen Arbor green. But no, he was talking about blue pebbles on the beach, bits of color at the waterline.

As a child I loved to search the shore near Empire and Glen
Arbor for pieces of beach glass. I treasured them as if they were gems,
and stored them in Band-Aid boxes organized by color, with shades of green
in one, amber and brown in another, white and Coke-blue in another. What
once had been sharp and dangerous had been worn smooth by waves,
the edges dulled, the corners rounded. The glass had been smoothed by the
same forces that grind granite into sand, but the lake's grit is one size too
coarse, and beach glass could use a final polish. It comes out of the lake
smooth to the touch, but the finish is pitted, causing each piece when
it dries to go dull and slightly dusty in appearance. Water fills the imperfec-
tions, making the glass shine as if it were lacquered, its colors vibrant. Then
it looks like ice nearly melted, or like the last stages of a Life-Saver melting
on your tongue.

I knew about blue beach glass, but I had never seen the blue
stones Gary Winans spoke of. He said they can be found only around Leland,
and that residents gather them after storms and display them in their win-
dows. Becky Thatcher fashions earrings of them, and kids collect them
with the same possessive ardor they sometimes give to Petoskey stones and
buffalo nickels. He pulled a handful from his pocket. They were dull and
unremarkable, vaguely blue. *Slag*, he said, relishing the inelegant noun. Then
he dipped his fist in a water fountain and opened his hand again and suddenly
it was alive with color, a palmful of shine in twenty shades of sky and lake.
The wet stones were the color of butterfly wings and morning glory
blossoms, of robin's eggs and menthol throat lozenges and Navajo jewelry.
Leland blues.

So, of course, I went searching, and on a bright windy afternoon
in September found fifteen or twenty blues of my own—the fruit of an
hour-and-a-half's hunt on the public beach in Leland. Some were tiny, mere
specks and baubles, while others were as big as my thumb. The smaller ones
were smooth and bright; the larger were pale as sky and speckled with flaws.

I placed them in a white ceramic bowl on my desk and added
enough water to keep them three-fourths covered. Now when the exposed
tops turn bland I like to swirl the water, washing them bright again.

At the historical museum in Leland I learned that those
blue stones are the byproducts of iron production, and date back to the early
years of the village. In 1869 a company from Detroit moved there, estab-
lished the Leland Lake Superior Iron Company, and built a blast furnace on

the north side of the river, immediately below the old mill dam. The furnace was ninety feet high, constructed of brick. It was fueled by charcoal made in nearby kilns and its fires were fanned to hellish temperatures by blasts of air driven by water rushing down a flume.

Iron ore from the Upper Peninsula was shipped to Leland by barge, where it was dumped into the top of the furnace and heated until it was molten. As much as forty tons of it a day emerged as pure iron, ready to be shipped to Detroit. The impurities — which happened to be tinted blue — were left behind in glasslike slag, which was periodically cleaned from the furnace and dumped into the lake. Only many years later, after being polished by waves and made scarce by time, did it become beautiful.

When I lower my face to the bowl of Leland blues I can smell, faintly, a rumor of whitefish, an intimation of sand, a hint of lake wind. I swirl the water and the stones gleam like blueberries in milk.

I place a small one in my mouth. It tastes vaguely sweet and salty, then like nothing, and is smooth and roundish and interesting, like running your tongue over the word itself: *slag*. It's only fun when you whisper it.

{ *Night Sky* }

AT NIGHT, EVEN IN SUMMER, the roads are mostly deserted. When activity is just starting in many other places, it is ending here. With the exception of the stream of losers and winners flowing between Traverse City and the casino in Peshawbestown, most of the roads are so empty that it seems like three in the morning at ten in the evening. If you're hoping for a late dinner, your options are limited.

Other than the mildly riotous weekend of the Polish Festival in Cedar, the Saturdays in summer when poets gather around a bonfire on the beach in Glen Arbor, and certain serendipitous evenings in taverns across the peninsula, the night life in Leelanau tends to be sedate. On North Manitou you can be entertained all night listening to raccoons ransack your cooler or backpack. You can drive dirt roads throughout the peninsula and jacklight deer. In the years when smelt ran in large numbers (they're disappearing now, displaced by more recent invaders), much activity occurred at

the mouths of rivers and creeks. On April nights you could be quite certain of running into friends clustered around Coleman lanterns on the beach, drinking beer and talking quietly, waiting for the run to begin. When the small fish finally charged the beach, they came in schools so thick that in the lantern light they looked like large dark tarpaulins undulating in the water, or maybe like giant manta rays. Everyone waded in and dipped their nets into the schools and lifted them heavy with hundreds of squirming, silver smelt. In fifteen minutes all your buckets would be overflowing, and you would have to spend the remainder of the night at your kitchen sink gutting fish and wishing you'd been more temperate.

Leelanau is not wilderness, of course, and can't be realistically compared to more remote places, but it suffers less from the pollution of artificial lights than most places along the Lake Michigan shore. If you sail up the lake at night, it's hard to take your eyes off the bright domes of illumination above Chicago, Muskegon, Milwaukee, and Green Bay, and the more general glow of the suburban sprawl that increasingly links those metropolises. Only a few portions of the shore are dark. Leelanau is notable for it.

Darkness is a keen pleasure to those of us who love the night sky, and by general consent the best place to be on a pleasant night is the beach. The sky is flung wide open there, and without the diluting glare of billboards and automobile dealerships, the stars are brighter than elsewhere and double in number if the lake is still. It's an ideal place to go during meteor showers, to watch auroras and lightning storms, and to count satellites and witness comets and lunar eclipses. Part of the attraction of the beach is that you can observe the sky while listening to the lake. Even on calm nights it makes noise—hushed sounds, like soft breathing—and creates the illusion that you are sitting beside a very large living thing. On nights when clouds cover the sky and no starlight or moonlight can break through, the wall of woods behind the beach is as black as the void, yet the lake remains faintly radiant. The silence can be immense.

If you become cold, or need company, you can build a driftwood fire that cracks cheerfully and fills the near sky with sparks. This is forbidden, I think, on the national lakeshore, so walk a little farther down the beach than usual, and when you put out the fire, bury the evidence.

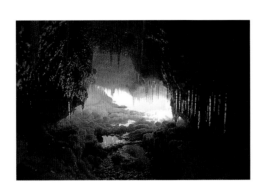

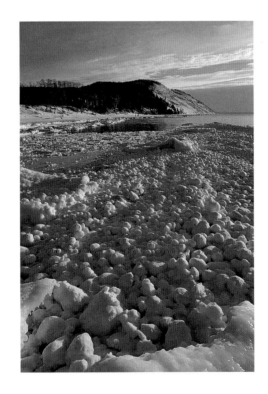

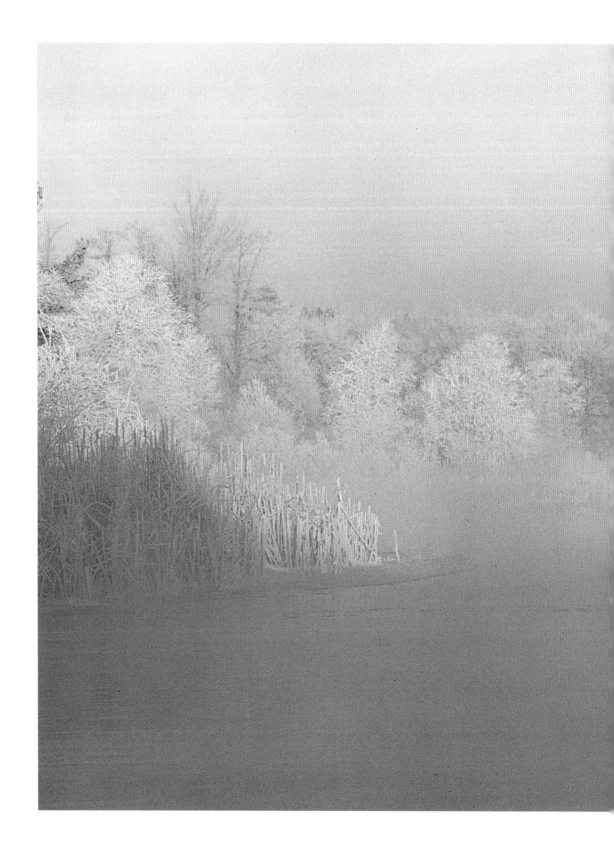

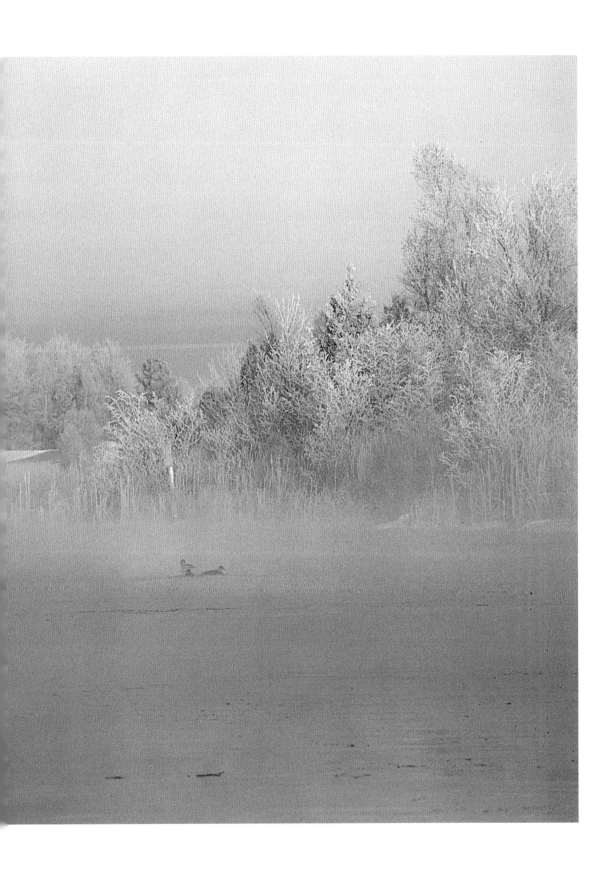

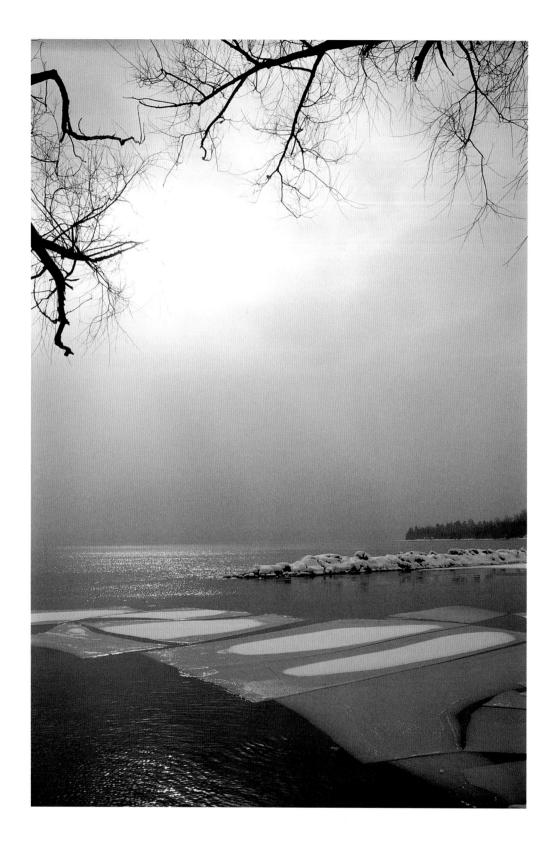

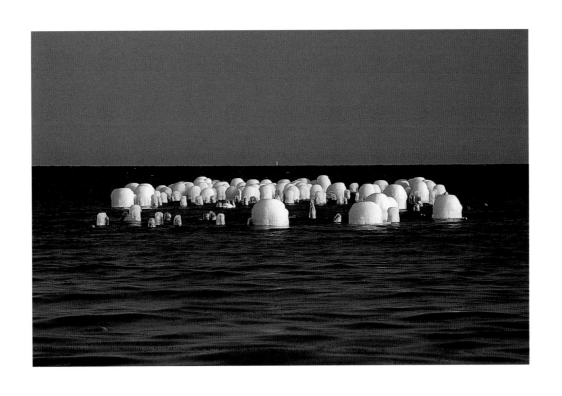

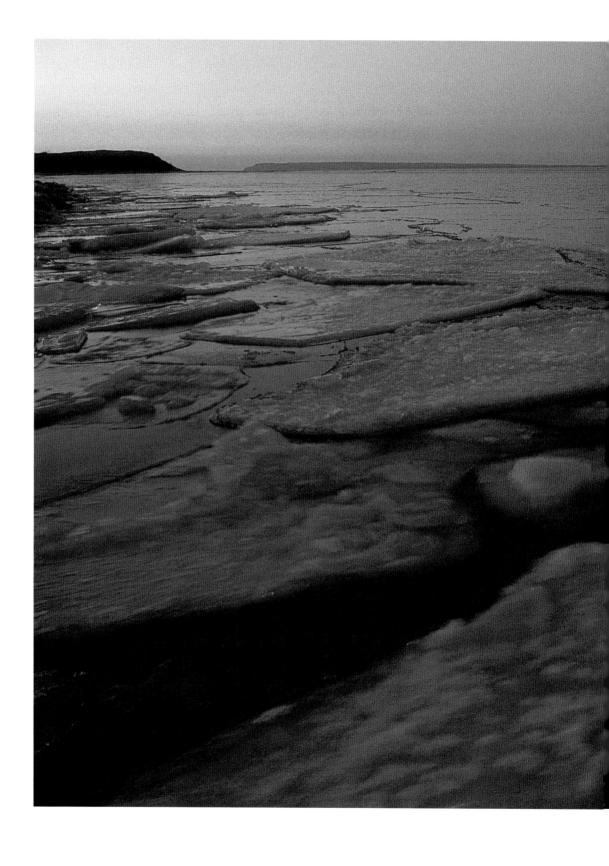

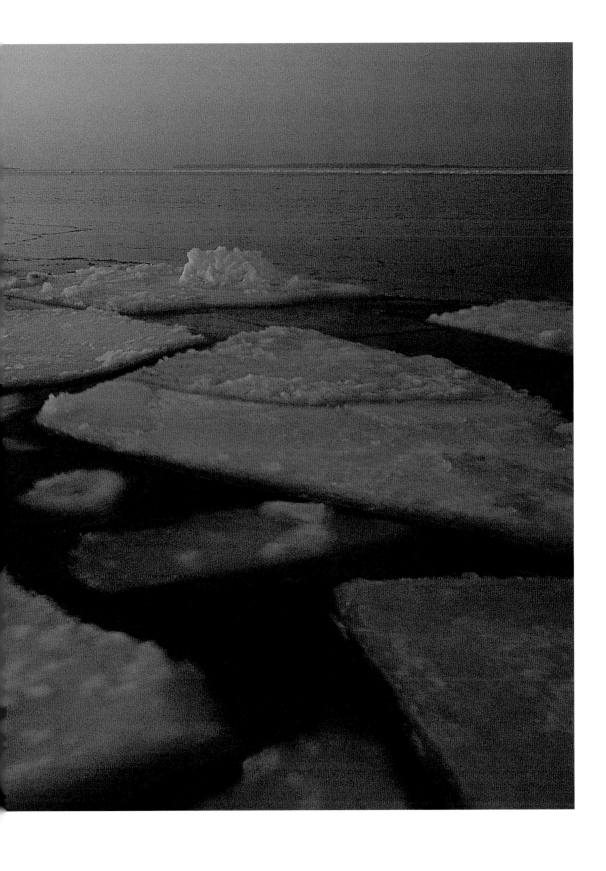

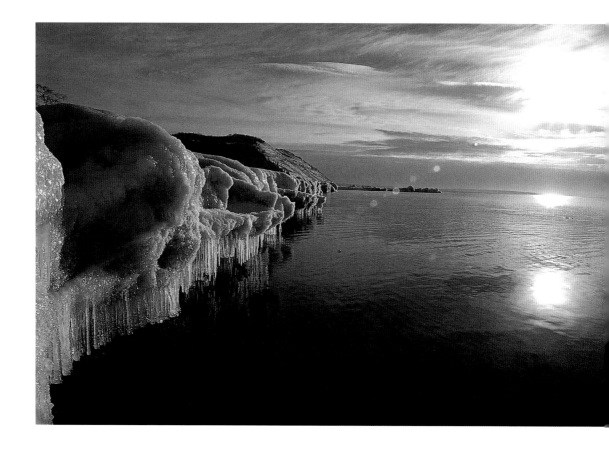

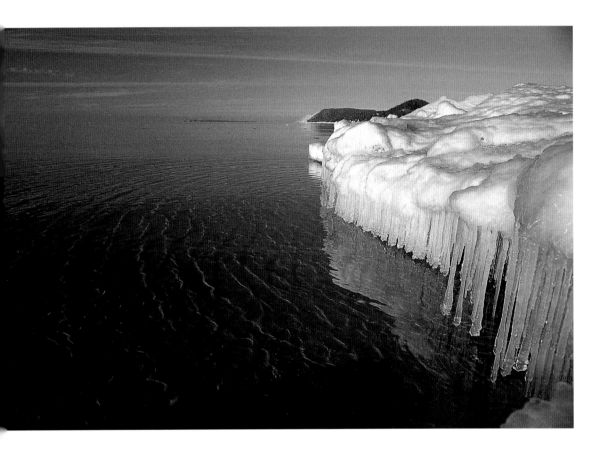

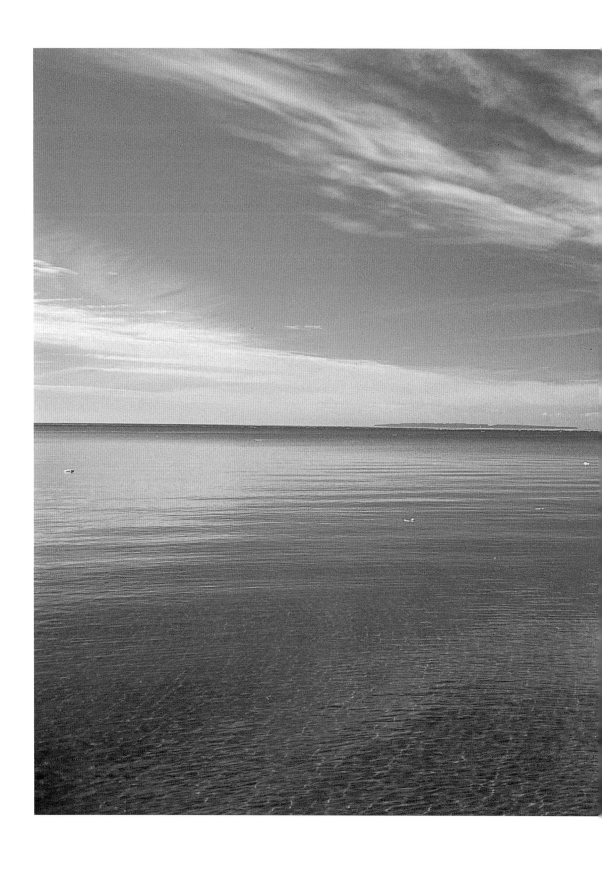

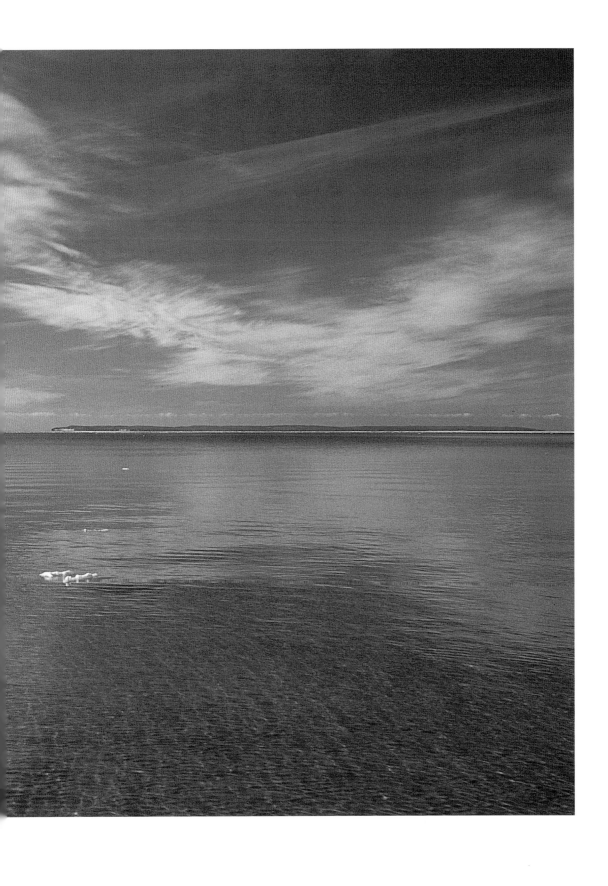

{ Beachwalking }

Nomenclature of the coastal zone, looking shoreward:

> *The shoreline is the edge of the water, where lake and land meet.*
>
> *The swash zone (or "wet beach") is washed by waves and always wet; is where waves sort stones and grind them into sand; is smooth if sandy, rough if rocky, and always invites beachwalkers.*
>
> *Berm crests (or "nips") are sharp rises of several inches to several feet built by waves at the top of their reach.*
>
> *The backshore is the zone of dry beach, above the reach of ordinary waves but not storm waves; is where driftwood and stones get stranded and only a few plants can live.*
>
> *Bluffs are banks built over millennia, and rise a few feet to a few hundred feet above the backshore.*
>
> *Foredunes are uneven, hilly dunes, well above the high-water mark, where exposed sand is scattered with coastal plants.*
>
> *Backdunes are larger hills and dunes, where trees and shrubs live among coastal flowers and grasses; are punctuated by blowouts of barren sand, eroded by wind.*

(Adapted from *Great Lakes Coastal Plants*, by Walter J. Hoagman.)

It changes every day. Yesterday's tracks are gone, the swash is clean, waves have carried a new miscellany to shore. Were I to walk this beach every morning for the rest of my life, it would never be the same. Even if it somehow grew dull with sameness, I could wait a week or two for a storm to make it new again. If still it seemed dull, I would not be a beachwalker.

Some days I return carrying driftwood, or with rocks so unusual I know they will amaze anyone who sees them, or with pockets rattling with mussel shells and beach glass, and always with cuffs full of sand. Years from now I might remember that I also brought home the scent of the lake, the mingling odors of approaching rain and distant decaying fish, of May's

honeysuckle breeze and January's arctic bluster. I might remember the conch-shell roar of wind in my ears, sunlight diamonding the water, the way the gulls kite in silence then bank downwind and laugh. If I'm very lucky I might remember a thousand details. But probably not. We miss so much, and forget most of the rest.

It's easy to overlook the little things. Curiosity, attention, and training are required to notice panic grass among the poverty grass, to know a Johnny darter from a ninespine stickleback. A botanist sees the butterwort in the swale and the aphids half-digested on its slimey leaf, but you and I will probably miss it. An ornithologist sees the particular bird—the piping plover, say, our rare bird of the shore, *Charadrius melodus*—while we notice a small shorebird the color of sand, if we notice anything at all.

But we can learn to notice. With practice we can begin to see the genus and the species, the general and the specific. It's our choice. We can become immersed in the physical world. We can memorize the dozens of goldenrods, or at least become aware that there are dozens to be learned. With training our eyes get better.

Every day for a month and a half I walked the shore of Good Harbor Bay. I was staying in a borrowed house on the beach, and in the mornings before work or after lunch or at the end of the day, depending on my mood and the weather, I slipped into boots and a coat and went outside. I walked through snow, watching it melt a little every day, then stood at the edge of the bluff and looked at the long arc of the beach below. Far to the left was Pyramid Point; to the right was Whaleback Mountain. Both are appropriately named, though Whaleback is a wooded bluff, not a mountain. Some days both promontories were obscured by mist or snow; other days they stood sharp against the sky. I always walked south, into the park, where no houses stood.

The beach curves for ten miles around the bay, and the dunes behind it are bordered by a low evergreen forest backing up to wooded hills. From a distance you can see that the evergreens grow on a level bench where the lake stood when it was twenty-five feet higher, some five thousand years ago.

I would walk a mile or two, always at least as far as the pilings where the Good Harbor docks once supplied steamships with firewood, and usually beyond. At first, large plates of white ice still clogged the shore and extended into the lake. The edges of the ice were tilted above the water

BEACHWALKING

145

and had grown beards and fangs where breaking waves ran over them. Beneath were caverns into which swells entered and made dull, subterranean explosions. A few blow holes still stood six or eight feet high, where water had spouted after every wave and built volcano cones of ice. On the sand were jumbles of iceballs tossed up from the waves—thousands of them, the size of golf balls and softballs, rounded but not round, smooth but flawed. They crumbled as the ice rotted, but remained translucent, spangled with sand.

By the end of the first week, when the temperature was easing into the sixties and already it was the warmest February on record, the ice disappeared. One morning it was simply gone, disintegrated, with only a few fragments half-buried in the sand. A slab the size of a fishing tug had been perched on top of the dock pilings. It was thirty feet long and ten feet wide and must have weighed tons. After a night of warm wind, it was gone.

Some days I walked the shoreline down the bay then climbed the bluffs, past clumps of dune grass, hay-colored and sparse, the stalks all leaning away from the wind, and returned to the house through rolling back-dunes. There, behind the beach, I followed sandy trails among plants I don't always know by sight but am enchanted with by name—hairy vetch and beach pea, spotted knapweed and seaside spurge, bird's-eye primrose, hairy puccoon. I walked among sweet gale, cinquefoil, ninebark, and sand cherry; around thickets of dune willow, red osier, creeping juniper; past stands of cottonwood, birch, spruce, and white cedar. Few trees grow tall in the dunes—the wind stunts even oaks and maples there—and many survive only if they cluster in thickets. Nothing can grow on the naked, shifting blowouts—each a patio of sand scooped from the side of a dune—but their edges are under siege by marram grass, broom grass, Pitcher's thistle, and pigweed.

<center>···❧···</center>

One morning I noticed that when the sun is bright you can see deep inside the rollers as they come in. It's like looking inside small moving hills of glass. A wave breaks and its froth makes a shadow that runs along the sandy bottom beneath the wave, like an obedient pet hurrying to keep up.

Funny what you see once you start paying attention. When the only ice remaining on the beach was locked in the sand, small ledges over-hung the swash zone. From each ledge came steady drippings of meltwater,

a slurry of water and sand, and beneath each stream of drops were small stalagmites. They were columnar and bulbous, khaki colored, an inch or two high, stacked with hanging bellies and plump rings of sand. In shape they were vaguely human, like tiny fat people clothed in automobile tires, each with a cup on his head to receive the next drop of water and sand.

I was walking on the dry sand above the water when I noticed all around me rocks and pebbles that seemed to have been stranded there. Thousands of them, probably millions, teeded up like golfballs, with all their shadows leaning the same way. Why had I never noticed this?

I got down on my knees and only then saw that the wind carried a constant stream of sand a few inches above the beach. Within that stream grains rolled and bounced, going airborne for a moment, then falling, bumping one another and bounding away, dropping into eddies behind pebbles, lifting again and tumbling downwind, flowing around stones like water around boulders in a river. I stood and saw that the aggregate billions of those grains formed smokey white drifts flurrying over the beach. Each drift raced along, covering large expanses, like the shadow of a cloud sweeping over a hill, but shimmering brightly as the single grains spun and caught light and moved on. The sand flew up the beach, leaving the heavy stones behind. Somewhere dunes were being built.

On the dry sand of the backshore:

> *Desiccated alewives the size of willow leaves; flat, gray, curled twists of skin and ribs with prominent eye sockets; they weigh nothing; they crumble between my fingers like leaf duff, and have no odor whatsoever.*

> *Zebra mussel shells, each the size and shape of a pistachio shell, their dark stripes faded by sun to pale white; others are wadded in clusters as big as fists, cemented with strong black threads.*

> *A winkle shell—tiny spiral snail of the lake—colored the rich deep maroon of storm clouds, with a stripe of white as thin as a needle point tracing the spiral from base to tip.*

> *The wing feather of a cormorant, large and boldly black, bedraggled by water, its hollow stem translucent.*

A tangle of ribbons, red, pink, and white, and the knotted blue stem of the balloon that carried them aloft last summer.

A Snickers wrapper, bleached almost white.

A twig of driftwood, with remnants of bark clinging to it like peeling skin.

A driftwood heron, long neck curved, woodgrain rounding the belly with zebra stripes.

A plastic straw, white with red stripes, packed with sand, the tip dented with teeth marks.

A twist of nylon rope, yellow, a foot long, its strands separating.

A pink hairbrush.

The carapace of a crayfish, fragile and weightless.

A black plastic handle of some sort, vaguely palm-shaped, with a large hole at one end and three small holes at the other, and stamped in the middle: "Taiwan Pat. 42126."

Nature makes us recognize our lives for what they are: small and temporary. That's good. It's a good place to start. We're small, but not unimportant. We're temporary, but we have enough time.

We walk on the beach, and look, and walk farther and look harder, and sometimes the effort is rewarded and sometimes it's not. Thoreau did not just walk, he sauntered, like a medieval pilgrim, *a-Sainte-Terre*, walking a path to the Holy Land. We are pilgrims too; wherever we find ourselves is holy. We place every step firmly on the earth, upon a thousand earthly particulars. Within the molecules and atoms of those particulars—every grain of sand, every pebble and mussel shell, every lapping wave—is light, if our eyes are open to it. Walking, sometimes, when we are receptive and persistent or simply lucky, opens our eyes.

To what? The real world, of course. The world as it is, apart from our ideas of it, stripped of our opinions, convictions, prejudices, political agendas. The raw, whirling, boundless reality of it. Seeing it and being seen by it we become enveloped in it, enwrapped it in, *rapt* in it. The experience

is transcendent, not because we can see beyond the world or above it, but because we can at last see into it.

Nature does not make good diversion. If we go expecting to be entertained we're usually disappointed. Not much happens. It's often boring. Tourists line the roads of Yellowstone holding cameras to their eyes, waiting for a bison or bear to do something memorable. They'd be more satisfied in front of a television set or a movie screen. I've paid my way, they seem to say, now amuse me.

Movies and television can make us forget for a few hours that we have problems and will one day die. I'm all for it. Save me a place in line.

But television and movies are frequently sensational and shallow, and shallow sensations are not enough. They don't satisfy; they always require more. Step outside afterward and you're back in the world, not much changed from who you were before the lights went down. Step into your life after being outside and you're stronger, braver, clarified. You've faced your problems, not avoided them. Powerful emotions have been embraced, important decisions have been made. Being outside in the world encourages you to look deeper into what it means to be a conscious human being in a complex age. It makes you aware that humans are not apart from nature, that regardless of our solipsism, arrogance, alienation, and destructive history, we somehow fit into the puzzle.

Nature demands encounter and requires engagement. It's the opposite of escapism. Once we've met its terms it *reminds* us that we will die, which reminds us to live.

On the wet sand of the swash zone:

> *Swash marks, the tracks of departing waves, like relief lines on a contour map or strips of paper torn to represent receding hills.*

> *Scattered zebra mussel shells, their halves intact and open, like moths with spread wings, marked as intricately as grouse feathers.*

> *More zebra mussel shells (three years ago they were scarce here; five years ago there were none), the mother lode, a hundred for every foot of swash, a Milky Way of mussels as far as you can see down the shoreline; when you walk on them they make a sound like crackers being crushed.*

Racoon tracks wandering from wet sand to dry sand to wet;
a pause to nibble mussels, then crayfish for breakfast and a neat pile
of legs left behind.

Swash marks again (they're worth a second look), pale lines drawn with
a stylus, accented with the dark stipples of minutiae—bits of weeds and
wood, drowned insects and their assorted legs and antennae and wingcases,
fragments of mussel shells, pebbles the size of birdshot—undulating in
dark lines down the beach, like dots on a seismic graph or like the tracks
of beetles or like lines of small black type.

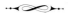

Say there was a storm, and all night you lay awake in bed listening to the wind in the trees and to the distant muted detonations of waves. In the morning you dress in a winter coat and wool hat and walk down the bluff to the beach.

It has been swept clean; everything that was loose has been washed away. The sand is wet and fresh, the water calm. The sky and the lake are the same shade of gray.

Suppose you start walking down the strand. The beach ahead looks like a diminishing corridor, with a door at the end. It occurs to you (we're speaking hypothetically now) that we pass through many corridors in our lives. In a way our lives are one corridor after another, and at the end of each is a door. You've been thinking about doors a lot lately.

Every day, in all weather, you have walked this same beach, and every day you have found yourself traveling a little farther down its corridor. You have been nudged along by sand, sky, and lake. You know that sand doesn't have an opinion, that sky doesn't care. You know that a lake is just a lake. But lately all that water feels like eternity.

Say you've been seeing the hand of time everywhere you look. You see waves crushing rock into sand. You see ice plowing sand into hills. You see hills tumbling an inch every century into valleys. It seems to take forever. It takes no time at all.

You've been laughing about it with your friends. The way time passes sluggishly, then in torrents, turning you into geezers. Gray hair and bad backs. And don't even get started about knees. Anyone know where you put your glasses?

Hey, everybody gets old. It's one of the most common experiences. Anywhere you go you can find an expert.

But let's be honest. You didn't really think it would happen to you. You thought they would make an exception in your case.

Let's say (hypothetically, hypothetically) that whether you want to or not you're coming to that door. You've tried to avoid it, have dragged your feet, have followed every detour. But you're getting a little tired of resisting it. And maybe getting tired of resisting it is precisely how you gain entry. You step through.

Goodbye youth.

Well, damn.

Goodbye frivolity. Goodbye vanity and foolish male posturing.

Goodbye, goodbye.

You expect to find it terrible on the other side. You expect it to be empty and cold over there. You expect it to be hopeless.

Instead you find some clarity. And a measure of humility. And even some peace. And you like it. You like it very much. You like it even knowing that this was just the beginning, that more doors lie beyond, some much tougher to enter and only a few of them hinged both ways, and from now on it'll be one damned thing after another, and much of it serious business, and some of it the most serious business of all, and that's okay too.

All of this is only supposition, of course. It has never happened to anyone you know. It has never happened to you.

But it could.

Beaches are dangerous like that.

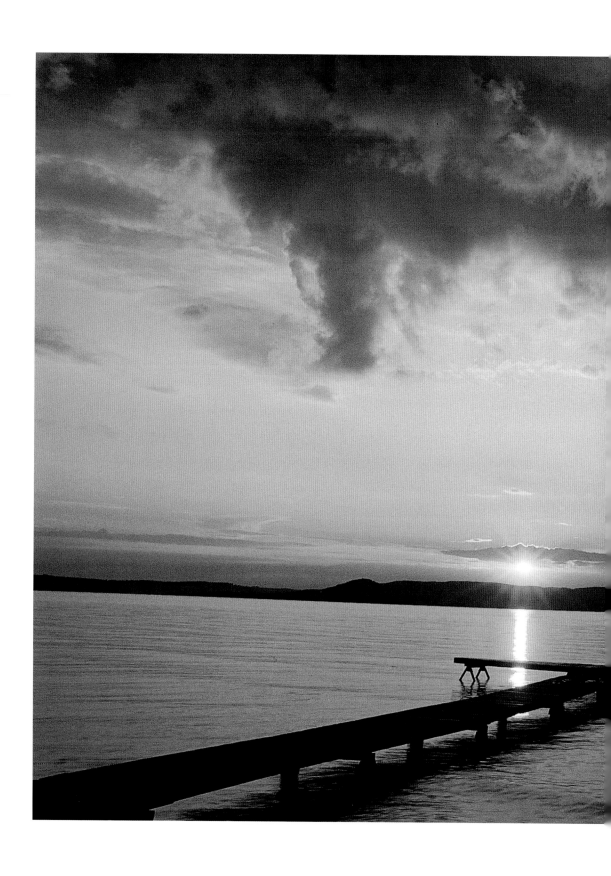

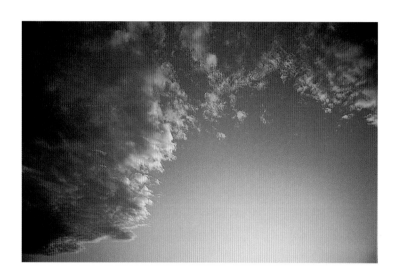

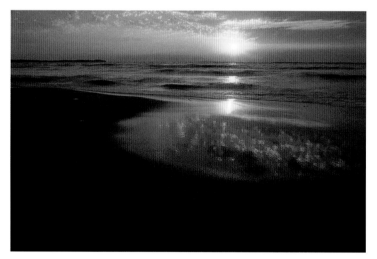

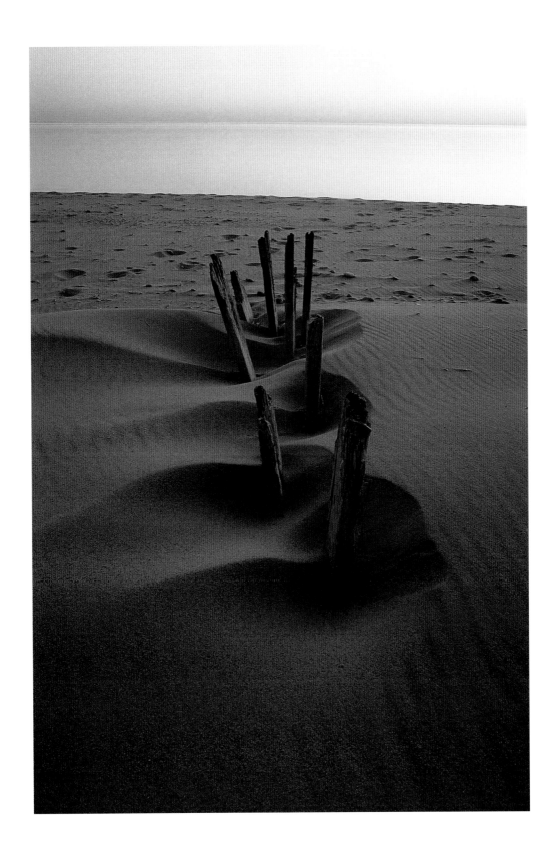

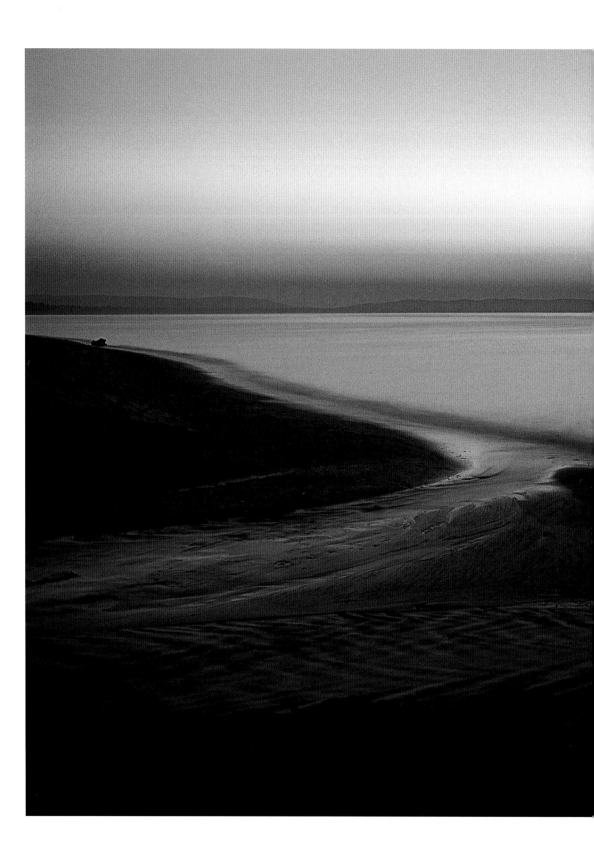

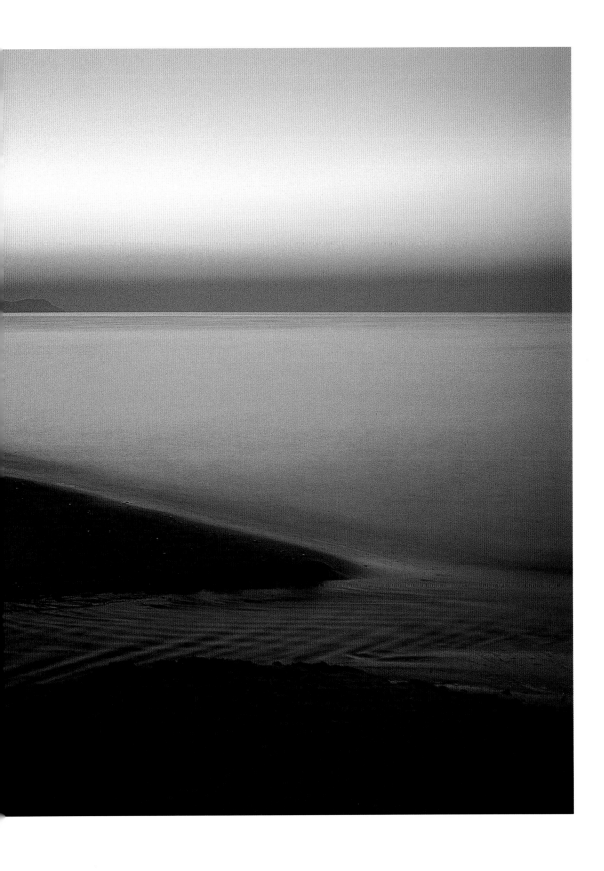

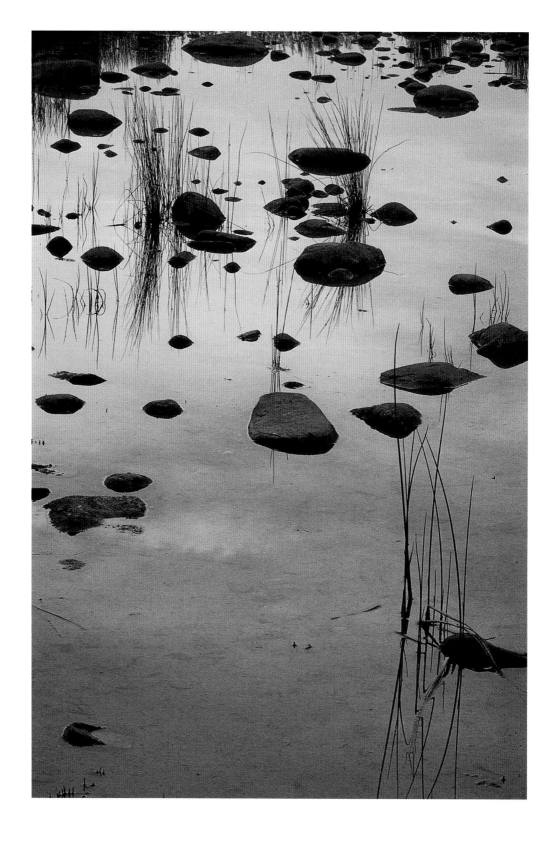

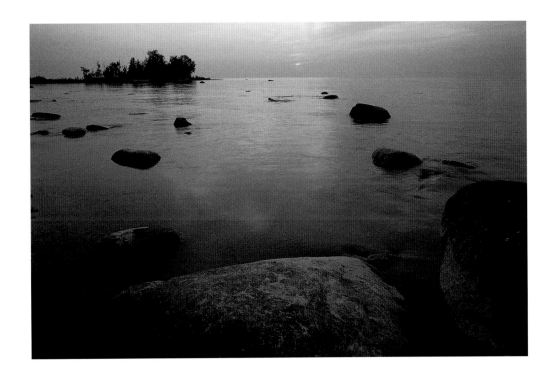

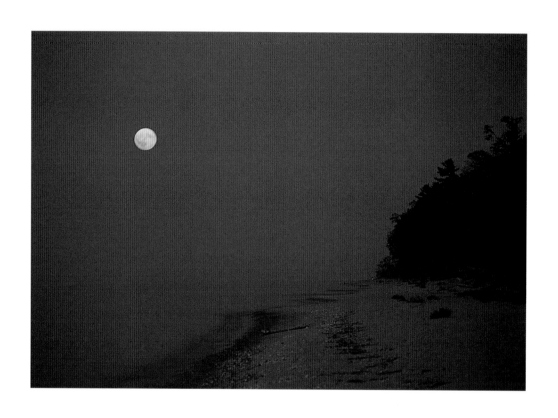

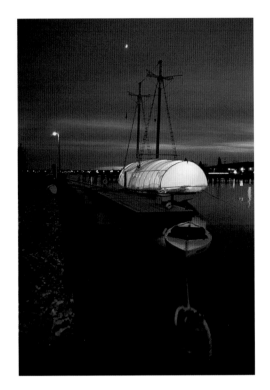
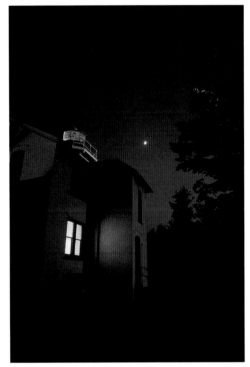

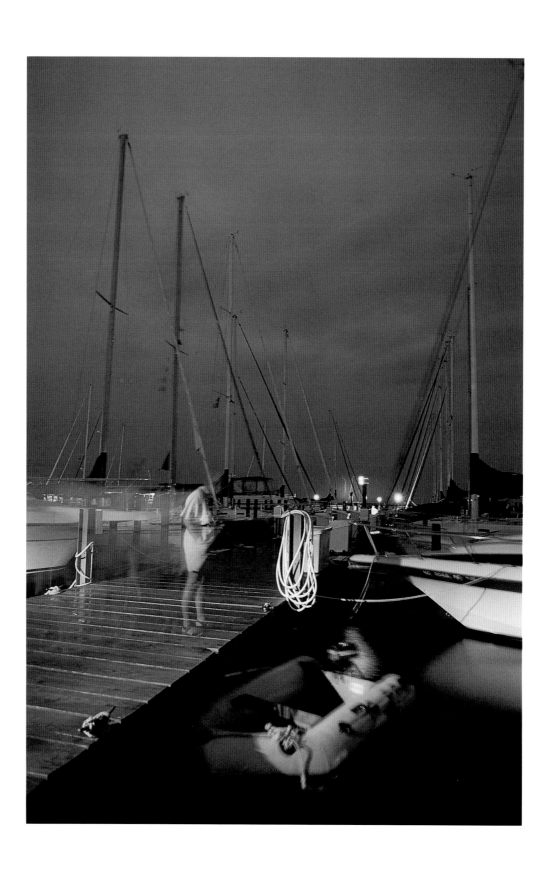

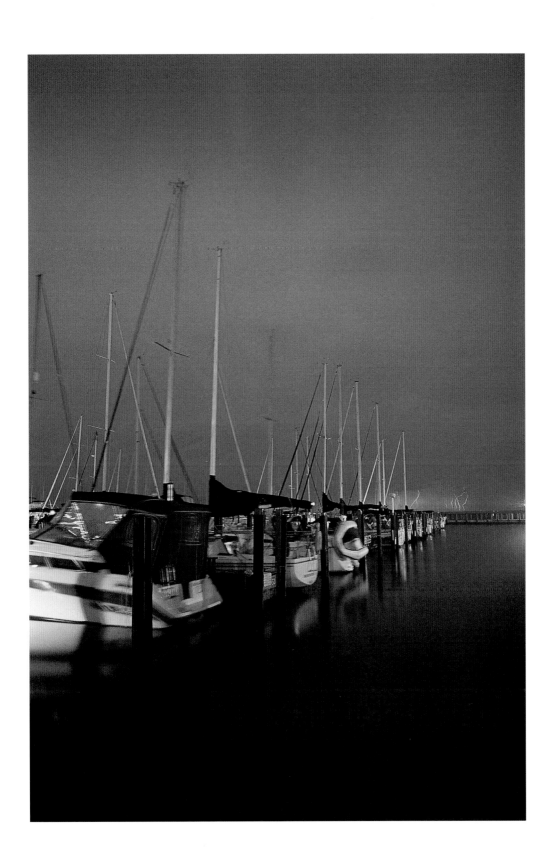

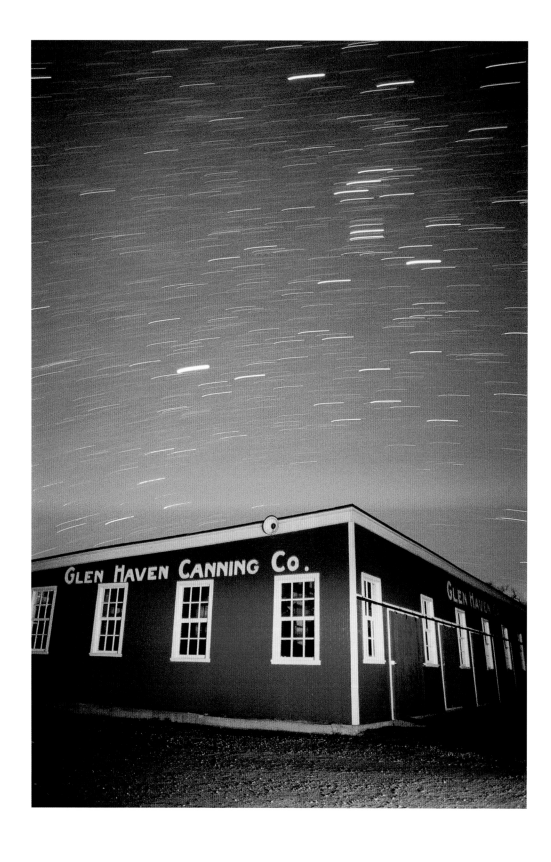

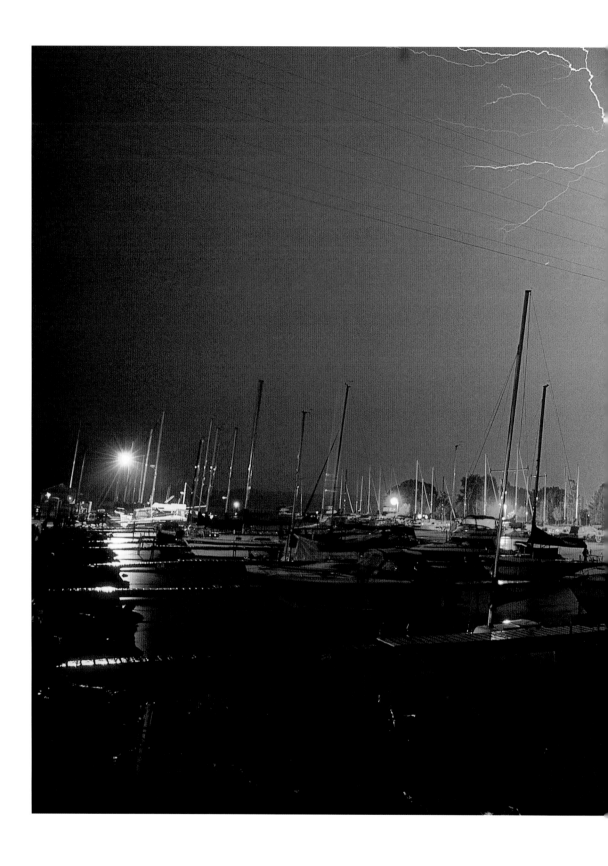

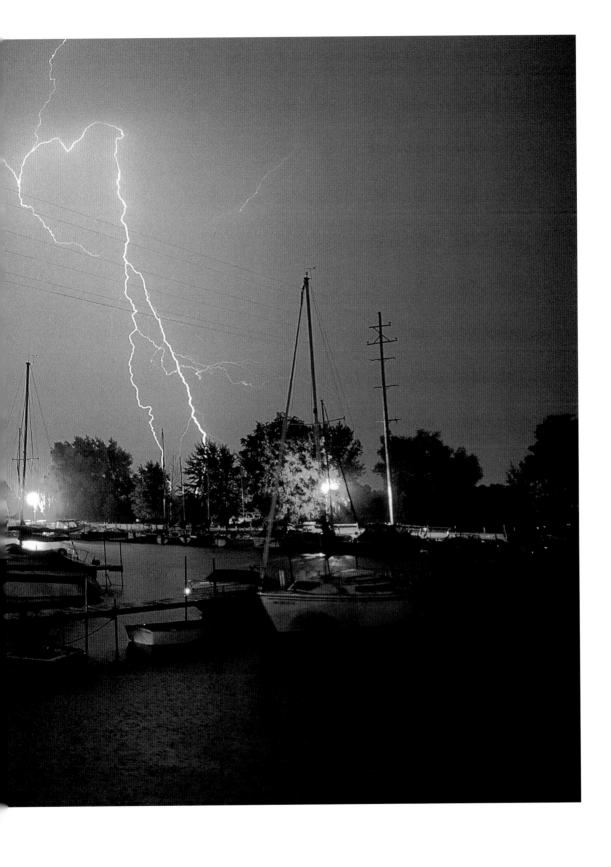

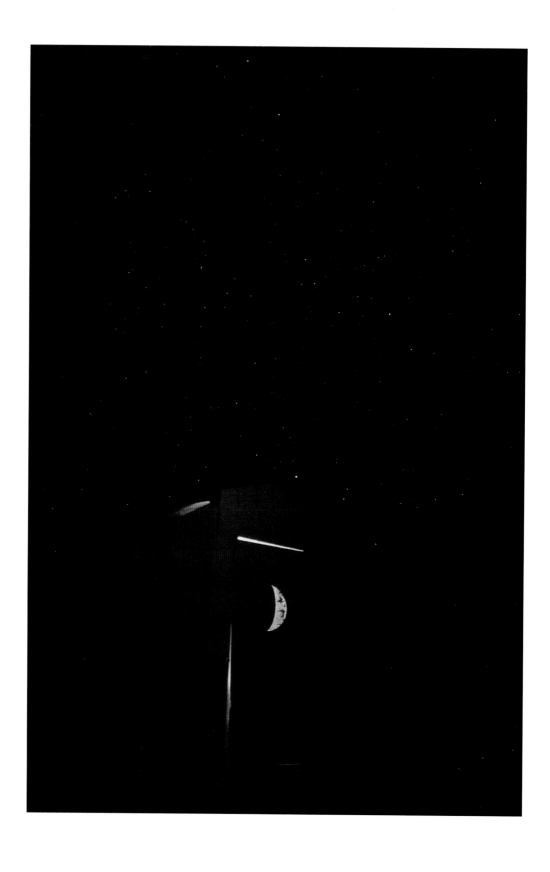

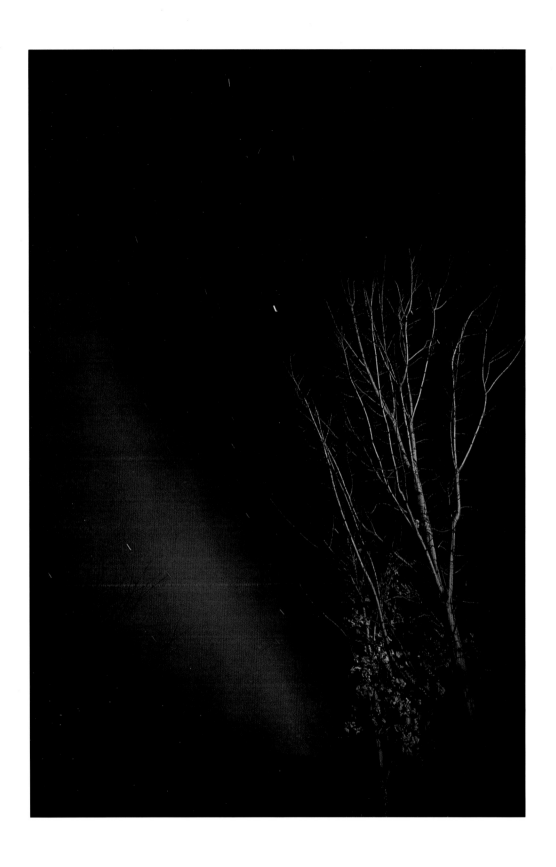

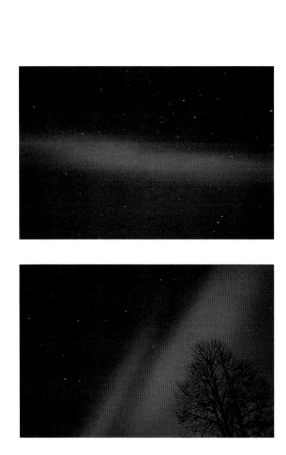

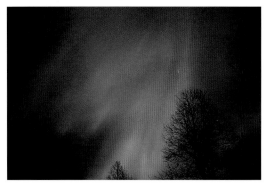

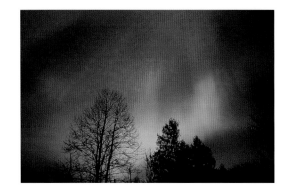

{ *Ken Scott* }

IN MEMORY OF:

Larry Brendin Joseph Scott Reimbold
December 12, 1947–April 27, 2000
and
Charles B. "Jiggs" Johnson Jr.
May 24, 1918–December 13, 1998

ACKNOWLEDGMENTS

The danger in naming names is to
unconsciously omit someone...
thank you to the following, plus the
thousands of you who support my vision:
Jerry Dennis
Tom Ford
Dianne Foster
Don and Ann Gregory
Stuart Hollander
Bob Martinson
Emily Mitchell
Gail Robinson
Trevor Scott
Jane Scott
Stan Silverman
James Williams
The Business Helper
Inland Seas Education Association
The Leelanau Conservancy
Leelanau Interiors

{ *Jerry Dennis* }

ACKNOWLEDGMENTS

The author wishes to thank Barbara
Siepker of The Cottage Book Shop in Glen
Arbor for her encouragement and
suggestions; Laura Foster for her skillful
and gentle editing of the manuscript; Laura
Quackenbush of the Leelanau Historical
Museum in Leland for confirmation
of facts; Glenn Wolff for inspiration and
friendship; and Joanie Woods for generously
allowing me the use of her lovely and
inspiring beach house.

PHOTOGRAPHIC NOTES

When I was asked to caption this collection of photographs… I balked at the idea… mainly because my whole career is based on being a wanderer, one without a guidebook. Though I sometimes start with a map and an idea of where I'm trying to get, more often I end up where I didn't know I was going and seeing what I didn't know was "there."

I'll identify the better known landmarks and views, and some of the flora, but mostly I'd like to offer these images as a "smattering" of possibilities for your own wanderings… this is not a guidebook to the county.

Get down low, crawl in the dirt, roll in the grass, kneel in the surf, look at your world upside down….

> *"See" with your other senses as well as your eyes.*

Oh, yeah… and watch out for poison ivy….

LITERARY NOTES

Much of the historical information in this book comes from George Weeks' excellent Sleeping Bear, Yesterday and Today. *Weeks is the author also of* Mem-ka-weh: Dawning of the Grand Traverse Band of Ottawa and Chippewa Indians.

Additional facts were borrowed from 100 Years in Leelanau *by Edmund M. Littell.*

My knowledge of dunes flora is entirely derived from Walter J. Hoagman's engaging field guide, Great Lakes Coastal Plants *(Michigan Sea Grant College Program, 1994).*

For additional reading about Leelanau, I recommend Kathleen Stocking's Letters from the Leelanau, *a splendid collection of personal essays by a lifelong resident and gifted writer. I also enjoyed and learned much from Stephanie Mills'* In Service of the Wild, *an insightful and impassioned study of grassroots restoration of the land, with special emphasis on Leelanau County.*

Many of Jim Harrison's poems, essays, and novels include observations of people and places in Leelanau. See The Shape of the Journey: New and Collected Poems, *and* Just Before Dark: Collected Nonfiction.

Gary Winans' collection of poems, Across the Smooth Lens of the Lake *(Pudding House Publications, 1999), though not specifically about Leelanau County, is a charming meditation on lakes, children, and morning glories by a poet with great affection for Leelanau.*

Anne-Marie Oomen's book of poetry, Seasons of the Sleeping Bear *(Second Story Enterprises, 1999), is a lyrical and deeply felt celebration of nature in Leelanau by a very good poet who has made the county her home for many years.*

The Sleeping Bear legend is brought vividly to life in The Legend of Sleeping Bear *by Kathy-Jo Wargin (illustrated by Gijsbert van Frankenhuyzen), and in* Mishe-Mokwa and the Legend of Sleeping Bear *by Gloria C. Sproul (illustrated by Nancy Behnken).*

Two useful and entertaining guidebooks to the region are Seasons of the Leelanau *by Sandra G. Bradshaw, and* The Road Guide: Sleeping Bear Dunes National Lakeshore *by Susan Stites.*

BIOGRAPHIES

Ken Scott's photography is the result of over fifteen years "experience" with "lots of patience... recognizing the right place at the right time, but not necessarily for the intended image." A self-taught photographer, he works with one 35mm camera usually on a heavy tripod and either a 24mm or a 105mm lens, along with Fuji's Velvia slide film (ASA 50). (A 300mm lens was used for a couple of shots.)

Ken lives with his two children, Trevor (age 12), and Jane (age 10), in Leelanau County, Michigan... near the Sleeping Bear Dunes National Lakeshore, where he finds much inspiration for his work. He is represented by various galleries in northern Michigan and has four previous books of photography to his credit: Michigan's Leelanau County *(1988),* Still, Michigan *(1990),* Charlevoix *(1997), and* Up North in Michigan *(2000).*

You can see more of Ken's work: www.kenscottphotography.com.

Jerry Dennis has earned his living as a writer since 1986. Since then, his essays on nature have appeared in such publications as Audubon, Smithsonian, Wildlife Conservation, *and the* New York Times, *have won numerous awards, and have been widely anthologized. His previous books, including* It's Raining Frogs and Fishes *(1992),* A Place on the Water *(1993),* The Bird in the Waterfall *(1986),* The River Home *(1998), and* From a Wooden Canoe *(1999), have received national acclaim and have been translated into five languages. In 1999 he was the recipient of the Michigan Author of the Year Award presented by the Michigan Library Association.*

Jerry lives in a 125-year-old farmhouse near Traverse City, Michigan, with his wife, Gail, and sons Aaron and Nick.

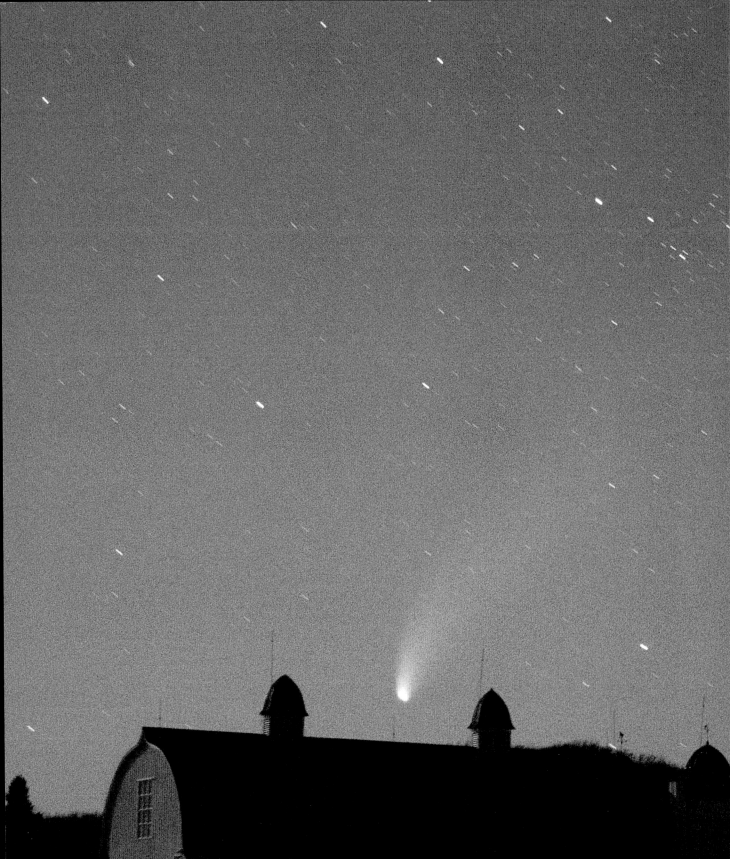

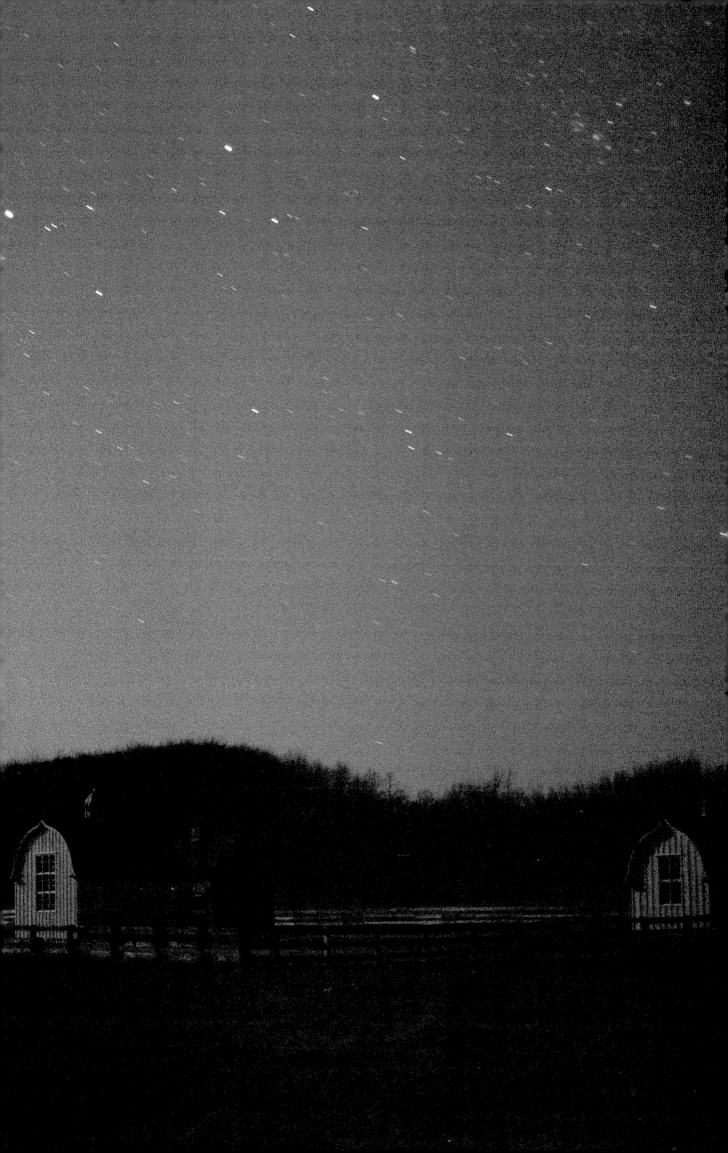

Individual prints of the photographs may be
available for purchase directly from the
photographer. Write to: Ken Scott Photography,
PO BOX 668, Suttons Bay, Michigan 49682.
Telephone: 231/271-6000
Email: kenscott@gtii.com
or: www.kenscottphotography.com

176

Cataloging-in-Publication Data is available from
the United States Library of Congress

ISBN 0-9662399-9-7

10 9 8 7 6 5 4 3 2 1

First Edition, First Printing, November, 2000
Printed and bound in Singapore by Imago

Designed by Emily Mitchell and Tim Nielsen,
assisted by Jane Kowieski, Nielsen Design
Group, Traverse City, Michigan

Edited by Laura Foster, Port Huron, Michigan

Published by Petunia Press, Inc.
407 Bridge Street, Charlevoix, Michigan 49720
231/547-7323